'Signs and Images'

Signs and Images.
Writings on *Art, Cinema* and *Photography*

Roland Barthes

Essays and Interviews,
Volume **4**

TRANSLATION AND

EDITORIAL COMMENTS

BY **CHRIS TURNER**

Seagull
BOOKS

LONDON NEW YORK CALCUTTA

www.bibliofrance.in

The work is published with the support of the Publication Assistance Programmes of the Institut français

Seagull Books, 2023

Compiled from Roland Barthes, *Oeuvres complètes* (Éditions du Seuil, 1993–2002).

© Éditions du Seuil, for *Oeuvres complètes, tome I*, 1993 and 2002
© Éditions du Seuil, for *Oeuvres complètes, tome II*, 1993, 1994 and 2002
© Éditions du Seuil, for *Oeuvres complètes, tome III*, 1994 and 2002
© Éditions du Seuil, for *Oeuvres complètes, tome IV*, 1994, 1995 and 2002
© Éditions du Seuil, for *Oeuvres complètes, tome V*, 1995 and 2002

First published in English translation by Seagull Books, 2016
English translation © Chris Turner, 2016

ISBN 978 1 8030 9 274 4

British Library Cataloguing-in-Publication Data
A catalogue record for this book is available from the British Library.

Book designed and typeset by Bishan Samaddar, Seagull Books, Calcutta, India
Printed and bound by WordsWorth India, New Delhi, India

Contents

Gromaire, Lurçat and Calder

In autumn 1946, Barthes, emerging from almost eight years of treatment for his tuberculosis, was desperately looking for work. Though he had, between 1942 and 1945, produced at least seven articles for *Existences*, a magazine run by sanatorium patients who were students at the University of Grenoble, this text appears to be the first instance of journalistic writing by Barthes for a 'professional' publication. It was published on 15 January 1947, shortly before he was officially appointed librarian at the Institut français in Bucharest, a post he acquired through his old school friend Philippe Rebeyrol, and some six months before he was to meet Maurice Nadeau, who would commission more regular journalistic pieces from him.

Oeuvres complètes, Volume 1, pp. 91–5

The Saigon-based magazine *France-Asie*, which was published from 1946 to 1974, was founded by the French author and journalist René de Berval. In January 1947, it described itself as a monthly review of Franco-Asiatic culture.

At the time of writing, the artists Jean Lurçat and Marcel Gromaire were associated in France with a revival of the art of tapestry.

Their work figured prominently in the travelling exhibition which, in the English-speaking locations that it visited (including the Metropolitan Museum of Art in New York), bore the simple title *French Tapestries*. Alexander Calder (1898–1976) was equally in the public eye for his exhibition at the Galerie Louis Carré, not least because of the essay devoted to his work by Jean-Paul Sartre that appeared in the exhibition catalogue.

Works of art are potential battlegrounds between richness and spareness of style, and the opposition we may employ to express how a Bernini differs from a Philippe de Champaigne can also be applied today to a plethora of schools and experiments. There is the tradition of plenitude and passion and there is another of stripping and paring down. Three artists, chosen from among recent exhibitions, seem to me to lend themselves to what might be called a psycho-analysis of substance: Gromaire and Lurçat, who have each had a room of their work in the *French Tapestries* exhibition, and Calder, who is currently exhibiting at the Galerie Carré.

1 The reference is to the Galerie Louis Carré on the Avenue de Messine in Paris's 8th arrondissement.

Gromaire has understood the need to change his style profoundly in moving from canvas to hangings. Lurçat treats tapestry in an equally intelligent and similarly specific spirit, but his taste for graphic devices and for airy motifs free as flame makes these fine tapestries a decoration that remains deliberately pictural, as the domestic art of the eighteenth century often was. Gromaire's decorative style, by contrast, is genuinely monumental; his world looms from the wall as though it were the blossoming of his secret essence, and as though there were a deliberate contest of forces between, on the one hand, the wall which supports and delimits and, on the other, the forests, nets, tools, feathers and houses that make the world upright.

Developed to this degree, the sense of the vertical cannot simply be a remarkable submission to the mural—and hence inherently vertical—nature of tapestry. It is a mark of obsession and leads us to think there is a Gromaire mythology; Gromaire has built himself a particular, total cosmos, which is one of verticality. Like El Greco and his ovoid world of beams of light, drapery and curving faces, like Piranesi and his vast array of ropes and stairways, Gromaire is intoxicated with all that is upright, and beneath his brush everything stands straight; in each object, vegetal or human, he searches out the sheaf of fibres that make it stand; he opens out the curves or eliminates them, or sets them on a base, which is a subtle but powerful way of enhancing their constructive power. Gromaire strips reality of anything imponderable or invisible. His lights,

still and round like Baudelairian suns, are finite objects; they are bright balls casting their rays on nothing that is volatile or inexpressible. There is nothing powdery about his streaked, hardened skies, no draught of air in them. In *Le Printemps ou Paris* [Spring or Paris], the boat is no longer a bobbing object of uncertain movements and romantic departures, but a squat tug, seen front on—that is to say, as an essentially vertical thing. It is a hard spur set against the hard spur of the Cité, which also climbs away vertically. The sea, normally a milieu of lazy, vaguely vertiginous plasmas, is for Gromaire a things of masts precise as needles, Breton church steeples, fishing nets—all those things that traverse, straighten, enclose. The Earth is the supreme world of straightness; it is a mass of threads, of straight, hard fibres in the form of ears of wheat, scythes, pickaxes, hairs, wrinkles, heavy leaves, narrow bridges over rivers standing erect on the canvas, trees, woodmen as upright as tree trunks, their hair like twigs. Perhaps, in this extolling of line, there is a nostalgia for the fibre as the first and last vegetal element, and perhaps the reduction of the world to an essential element runs through Gromaire's art as it ran through Berkeley's philosophy (tar-water) or Schelling's (oxygenism) and, in general, the imagination of all who were, to one degree or another, followers of Hermeticism.

The solid expressionism of the man of the North (Gromaire) is in no way opposed to the idea of a romantic transmuting of matter which is, after all, the dream of all formal art.

But Gromaire's verticality can be related to an even simpler element: in his work Nature particularly abhors a vacuum. And, with him, the sense of the vertical reduces ultimately to a sense of fullness. Verticality is the sign of a world held tightly poised, its elements kept upright, so as to hold up better against one another. Objects stand upright because they are tightly packed. They are held up by one another— humans, birds and objects are interdependent in space. There is a homogeneous substance that runs without distinction from the rabbit's right ear to the turkey cock's crest, from the scythe to the ear of corn, from wrinkles to brushwood, from the tower blocks to the ship's mast, and in it there is no room for thrills or dreaming. Uprightness here is the precondition for cohesion, and it is cohesion that is Gromaire's goal as a tapestry designer. Gromaire's universe has the molecular plenitude of the egg. This is the significance of *Landscape with Hoopoe*, for example, in which the *rondeurs*—always very firm and simple, never sinuous— contribute to the overall stability, lending the verticality of the whole the warmth of a perfect fullness. It seems to me that the bird theme, common in these Gromaire cartoons, must be understood as the presence of a particular plenitude, an ovoid, animal plenitude: Gromaire's birds (and his rabbits and some of his horses) are oval balls, within which, by a very straightforward transparency, the natural elements are stripped bare, reduced to the state of great naked lines. Plumages, limbs and tendons (and his turkeys' great

strips of falling skin) leave no room for movement; nature, self-contained and tautly balanced in a total plenitude, achieves the powerful fixity of primitive monumental art. Hence, it is barely necessary to say that Gromaire's verticality has nothing soaring about it; there is here no mystical élan. These great compositions have, strictly speaking, no sky and no base; every line is a straight one for lack of space and also because nature has, indeed, this unoriented plenitude. The soaring extension of El Greco's figures, for example, and the downward elongation of Modigliani's have nothing whatever in common with Gromaire's objects. Those objects aren't distorted; they are healthy, robust and concrete, elements of a cosmos that is beyond hope or despair, the way a rabbit, a harvest, a street or a woodcutter lie beyond all theology. This doesn't, however, prevent there being a more romantic Gromaire—particularly in canvases recently exhibited at the Galerie Carré—in which we feel the oppression of the solitude of forests, the apocalypse of fuliginous forms, woods as upright as dark organ pipes and ports sooted up to the point of darkness.

Lurçat, the other triumphant designer of the recent tapestry exhibition, is all combustion. He signs his name in letters of flame, and it seems to be the role of the great airy spaces in his compositions to provide his motifs with a more intense, more mobile flame. The fixed, hanging suns of Gromaire (and Baudelaire) here become whirling suns shooting out liquid flame, like

the eyes of El Greco's madonnas. Lurçat's birds aren't round and fat: what he mostly depicts are cockerels and his cockerels are plant-like; they are made of leaves and light. Every Lurçat composition is magnificent and wild, a thing of passionate, sharp elegance. His— crooked—woods, eschewing the austere straightness of Gromaire's, have immediately something of the airy thorn bush about them—or some other dry bush. Gromaire's plant material doesn't branch out but cleaves to a single, continuous, deliberate style of movement. Lurçat's is unpredictably bent, vermiculated. Gromaire's lines are always organized into a network that holds, solidifies and eternalizes. Lurçat's are invasive in the manner of divided waters that carry things along, that spread in a shifting, devouring lattice pattern and liber- ate. This is why his designs need so little in them: his sun beneath the table illuminates everything; his fish are barely more than captured water and occupy the whole of the light. There is a terrific, lively thirst in these magnificent tapestries. Never were objects touched by art raised to such a degree of incandescence.

———

Calder, who is currently exhibiting in Paris, exposes us to a different philosophy of substance. Over against Gromaire's plenitude and Lurçat's fires, Calder expresses the silent palpitation of spareness, the barren, fragile gracility of a world stripped of its sensual foundations. Calder the American (or Canadian) is, strictly speaking, neither sculptor nor painter. He designs and personally produces non-figurative objects, made from steel wires,

discs or sheets of metal, painted red, black or white. The technique goes back to the 'fabricated objects' of the Surrealists (Giacometti). However, Calder is an innovator in that his objects are mobile; very subtly articulated, and even lighter than flowers or branches, they stir into motion at the slightest draught (most are displayed hanging) and make highly complex, slow, silent movements in the air, taking an endless amount of time to settle again.

This slowness and these propulsionless movements stir a sense of oppression in us. There is no doubt that Calder has awakened here, with means pared down to the absolute minimum, terrors and charms reaching back into the depths of time. We might, without any great paradox, say this is a religious art; it bases its effects on certain correspondences of a cosmic order between invisible cause and visible movement. The silence in which the objects, themselves so meagre and forlorn, move slowly and unpredictably, would be tragic if they did not have in them, purposely I believe, something stunted and stifled. Sartre introduced Calder to a Paris audience. Calder and Sartre are both distanced from tragedy by the extent of their emphatic force and their rhetoric (Baudelaire spoke of the emphatic truth of gesture in the great circumstances of life), but only by that.[2] As a technique, the animation of art objects

2 The reference is to Charles Baudelaire, 'Exposition universelle, 1855. Beaux-Arts: Eugène Delacroix', Curiosités esthétiques (Paris: Michel Lévy Frères, 1868), p. 237. [Trans.]

may be of truly revolutionary importance. But for the moment what is poignant about Calder is that the artist who designed this—perhaps crucial—technique and dared to implement it hasn't used it to add to the triumph of substance and colour, but has immediately applied it to very spare, sparse forms from which all sensuousness is banished (though not all vice, for the strange is never pure). By giving them movement, he has removed all richness from them.

Up until now, if we sounded the depths of all stern or classical art, we would find an exaltation of the rational. What is being constructed now by a Sartre or a Calder is both free of any tenderness and absurd. It is the new form of the sacred—religious without theology and awe-inspiring without sumptuousness. The expressionism of Gromaire and the romanticism of Lurçat run up against this heartless, reasonless world and expire. The battle is on once more between richness and sparseness.

Cinemascope

Oeuvres complètes, Volume 1, pp. 456–7

Though differing in the style of its argumentation from the pieces that were republished in Barthes's *Mythologies* (which perhaps accounts for its omission), this short essay was initially published in the 'Mythologies' column of *Les Lettres nouvelles* in February 1954.

Henri Jacques Chrétien invented the anamorphic widescreen process, employing an anamorphic lens system known as Hypergonar, which was, strictly speaking, not quite cinemascope but its immediate precursor.

Though I have insufficient knowledge to be able to explain how Henri Chrétien's process works, I can at least judge its effects. They are, in my view, surprising. The widening of the image to the dimensions of binocular vision must inevitably transform the inner sensibility of the filmgoer. In what sense? A front-on viewing position, when it is extended, comes close to forming a circle or, in other words, the ideal space for great drama. Up to now, the spectator's gaze has been that of an individual recumbent and buried below ground, of a person walled up in darkness, receiving cinematic nourishment almost in the way a supine patient is fed passively through a tube or a drip. Here the position is quite different. I am on an immense balcony and move easily between the outer limits of the field, taking in freely what interests me. In a word, I am beginning to be surrounded and to substitute for my larval sensibility the euphoria of an even circulation between the spectacle and my body.

The darkness itself is transformed: in ordinary cinema it is the darkness of the tomb and I am still in the cave of myth; I have a little tongue of light flickering

a great distance above me and the truth of the images descends on me like heavenly grace. Here, by contrast, my connection to the screen is no longer threadlike. A whole area of light opens up before me. I don't receive the image from these long threads of light, which we can see piercing and nourishing the stigmatists, but I am leaning in to the spectacle along its full extent and am no longer a larva but, to some degree, a god, since I am no longer beneath the image but in front of it, in the middle of it, separated from it by that ideal distance required by creation, which is no longer the distance of my gaze but the length of my arm (God and painters always have long arms). The wider space obviously has to be occupied in a new way; it may be that the close-up won't survive or will, at the very least, undergo a change in its function. Kisses, sweat and psychology—all these things will perhaps go back into the shade and the distance. A new dialectic between humans and the horizon, between humans and objects must emerge, a dialectic of interdependence rather than foreground and background. This should be, properly speaking, the space of history. And, technically, the epic dimension is born. Imagine yourself watching *Battleship Potemkin* not from the end of a telescope but right in among the atmosphere, the stones and the crowd. This ideal *Potemkin*, in which you could at last reach out your hand to the insurgents, share the same light and be hit by the full impact of the tragic Odessa Steps, is now possible. The balcony of history is ready. It remains to be seen what you will

be shown from it—whether it will be *Potemkin* or *The Robe*, Odessa or Saint-Sulpice, history or mythology.

Cinema,
Right and Left

Oeuvres complètes, Volume 1, pp. 943–5

This article, published in *Les Lettres nouvelles* on 11 March 1959, was not presented directly as film criticism but as a further contribution to the 'Mythologies' column that Barthes had begun in 1953. Claude Chabrol's film *Le Beau Serge* (Handsome Serge), which is its subject, was released in 1958 to considerable critical acclaim (it won the Jean Vigo Prize for 1959) and is usually counted among the earliest examples of the French New Wave.

Recalling the opening images of *Le Beau Serge*, I tell myself once more that here in France talent is on the Right and truth on the Left; that it is this fateful disjunction between form and meaning that is suffocating us; and that we cannot manage to leave aesthetics behind, because our aesthetics is always a cover for conserving something. This is our paradox— that, in our society, art is both the extremity of a culture and the beginning of a nature; that the freedom of the artist simply ends up forcing a static image of man upon us.

I'd have given a great deal to cut out the plot from *Le Beau Serge*. I'm not even sure the story makes sense to its author. It's as though the plot becomes melodramatic because it is, in fact, immaterial; that the truth is in the style, the concessions in the subject matter and, by a paradox of structure, the essence of the narrative is merely an attribute of its form. Hence a general divorce between a truth of signs, an entire modern way of seeing the surface of the world—precisely, as surface— and an inauthentic conception of arguments and roles,

which are lifted nonchalantly from the crudest bourgeois folklore—the sort that runs from Paul Bourget to Graham Greene. Now, casualness of gaze can be a basis for sarcasm or affection—in short, for a truth—whereas offhandedness about the subject is the basis for a lie. No other art can bear this contradiction for long—the innocence of the argument very quickly wrecks the modernity of the form. The terrible thing about cinema is that the monstrous is viable on film. We might even say our entire avant-garde thrives on this contradiction—true signs and a false meaning.

The entire surface of *Le Beau Serge* is right (except when it is expressly conveying the story—the snow is wrong, for example): the fields, the village, the hotel, the square, the clothes, the objects, the faces, the gestures—everything that has lasting presence in our field of vision, everything literal, everything that merely signifies an insignificant existence or whose signification lies far outside the awareness of the participants. There is a basic elegance in this whole opening of the film: thankfully, nothing happens but a subtle defiance of rural existence which is *given a sudden pinch*—as it had to be if we were to have something worth watching—by a young bourgeois bursting on the scene, a young man in a duffel coat and flowing scarf who reads *Les Cahiers du Cinéma* as he sits drinking his substandard cafe-made coffee. So long as it refrains from presenting us with the monster that is the Story, this skimming of reality is right and proper—that is

to say, it is a delight. Personally, I could have done without the Feeling. I could have spent hours happily watching this double existence unfold, encapsulated in its most intelligent signs; could have savoured the rightness of a description whose object isn't the village itself (nothing gets on one's nerves as much as rural realism or the gritty depiction of alcoholism) but the patient dialectic that unites the young dandy's urbanity and the unsightliness of 'Nature'. All in all, what is good in the film is what we might term its micro-realism, the subtlety of its choices. There is in Chabrol a power of *correctness*: for example, in the football match the children play in the street, Chabrol has managed to find the fundamental gestures, the ones that convince us with what Claudel called the 'detonation of obviousness'. Formally, in its descriptive surface, *Le Beau Serge* has something Flaubertian about it.

The difference—and it's a sizeable one—is that Flaubert never wrote a *story*. With a profound understanding of what he was about, he knew that the value of his realism lay in its insignificance, that the world only signified that it signified nothing. Flaubert's genius lay in the awareness of—and courage to accept— this tragic deflation between signs and signifieds. By contrast, having set his realism in place, Chabrol instils a pathos and a morality into it—in other words, whether he wishes to or not, an ideology. There is no innocent story—Literature has been wrestling with that unavoidable fact for a hundred years. In a way that

is both excessively ponderous and excessively offhand, Chabrol rejects any eschewing of plot. He goes all out to tell a story and produces a 'moral': *You can save someone if you love them.* But save them from what? What does handsome Serge suffer from? From having had a deformed first child? From being a failure socially? Is his problem, more generally, that of his village, which is dying because it has nothing, is nothing? It is in the confusion of these questions and the immateriality of the answers to them that a right-wing art is defined, which is always concerned with the discontinuity of human troubles, never the connections between them. The peasants drink. Why do they drink? Because they are very poor, because they have nothing to do. Why this misery, this forlornness? At that point the investigation comes to a halt or shifts to a higher level—no doubt they are stupid in essence; that is their nature. Of course, I am not asking for a course in economics on the causes of rural destitution. But an artist has to know that he is entirely responsible for the *end point* he assigns to his explanations—there is always a moment at which art freezes the world, and the latest possible moment is the best. What I call right-wing art involves this fascination with immobility, which means that outcomes are described without any questions ever being asked—not about causes (art cannot be deterministic)—but about functions.

Handsome Serge's despair relates, one way or another, to the whole of France. Therein lies the basis

of a true art. And since a work isn't a graph, a balance sheet or a political analysis, it is through the relationships between its characters that we grasp the totality of the world that makes them. In Visconti's film *La terra trema* [The Earth Trembles], the relationship between the two brothers comes gradually to take in the whole of Sicilian capitalism; the impossible love between the sister and the young mason has about it the crushing weight of the whole world. Because Chabrol chose to endow his creations with intense relations, his village remains something quaint and conventional. This is a 'human' drama in a 'particular' setting, a formula perfectly expressive of that inversion of the real that Marx described with regard to bourgeois ideology since, in fact, here it is the drama that is 'particular' and the setting that is 'human'.

All in all, what the plot enables Chabrol to sidestep is the real. Whether resistant to the idea of giving his world a depth and a social geology of the kind offered by Balzac, for example, or incapable of doing so (the young cinema has nothing but scorn for the outdated *lourdeurs* of committed art), he has nonetheless rejected the ascetic Flaubertian approach, the desert of a realism without signification. Too refined to admit 'politics', he is too complacent to at least impart an ethical sense to that rejection. Melodrama (in the form of this insipid story of snow and childbirth) is the enormous bag of wind into which he evacuates his irresponsibility. *Being good*? Does Chabrol

think all that matters is to wish to be so? It is when Chabrol's film ends that the real problem begins—the essence of goodness doesn't absolve you from finding ways of being good and those ways are interconnected with the whole world, so that you can never be good all on your own. It is a pity these talented young people don't read Brecht. They would find there at the very least the image of an art that knows how to start on a problem from the exact point where they believe they have finished with it.

The Problem of Signification in Cinema

The following article appeared in *La revue internationale de filmologie* in the issue of January–June 1960. The journal was founded in 1947 by Gilbert Cohen-Séat. His 1946 work *Essai sur les principes d'une philosophie du cinéma* has been described by one historian as its underlying 'charter'. Other leading members of the Centre for the Study of Mass Communications, such as Edgar Morin and Georges Friedmann, were major contributors to the journal which played a key role in the more 'sociological' strand of French cinema studies.

The film *Bob le Flambeur* which is referred to in the text was directed by Jean-Pierre Melville and appeared in French cinemas in August 1956.

Oeuvres complètes, Volume 1, pp. 1039–47

In certain film images, there is a purely intellective content. Quite apart from any emotional or even merely argumentative power, these images aim to teach us, or inform us of, something. In other words, some elements of the image are genuine *messages*. Now, the message—or sign—is an analytic reality that increasingly preoccupies modern research. Various disciplines have taken an interest in it on very diverse grounds: cybernetics, logistics, psychoanalysis, structural linguistics and ethnology—all these sciences are probably tending to merge into a general science of communications, whose new unity might be said to lie in signification. The performing arts are clearly a privileged field for semiology, and a good forty years ago the linguist de Saussure suggested that dumb show [*le pantomime*] be studied as a genuine linguistic system. Admittedly, film cannot be defined as a pure semiological field; it cannot be reduced to a grammar of

signs. Yet films are fuelled by signs elaborated and arranged by their authors for their audiences' consumption;[1] they have a partial but indisputable role, in the great communicative function, of which linguistics is merely the most advanced part. What we would like to outline here are the frameworks—for the moment very crude and, naturally, hypothetical—of a semiology of the filmic image.

———

Before coming to the study of the communicative chain, we have to make a brief comment on the ends of that chain.

1. *Who sends the message?* It is clearly the author of the film. In accordance with the general argument it falls to him to set out and the personal style he intends to impart to his narrative. The invention of signs is carried out within precise limits which the author cannot

1 Barthes uses three different terms in this article for those who make films: *auteur, metteur en scène* and *cinéaste*. While I appreciate that it is unusual in English to speak of the 'author' of a film, except in a legal context, I think there are grounds for employing this literal translation in a piece of this theoretical nature. To have retained the French term auteur would have created an allusion to a debate about filmmaking that is not being referenced in the text. I have, therefore, rendered the three terms as author, director and filmmaker respectively. [Trans.]

transgress without becoming unintelligible. However, within these limits, the reserve of signs is very fluid; the author can derive the force of his message from a sort of collective lexicon developed by tradition, a positive *koine* of the filmic sign, or, by contrast, from a symbolism that is universal in nature but consumed more or less at the unconscious level and made up, for example, of all the Freudian symbols (water is openly a sign of birth in some images by Pudovkin and Bergman; erotic symbolism is plentiful in the history of film and draws most often on *mediations* well known to psychoanalysis). We might say that the reserve of messages from which the author can draw divides up into concentric zones. The most highly used core of this reserve provides the basis for a veritable rhetoric of filmic signs (calendar pages torn off to indicate passing time). The peripheral zone is made up of what we might call *decoupled* signs, in which the affinity between signifier and signified is, to some extent, loose or unforeseen: it is clearly in this zone that the art or originality of the director lies. We might say that the aesthetic value of a film is a function of the distance the author is able to introduce between the form of the sign and its content without overstepping the limits of intelligibility.

2. *Who receives the message*? This is clearly the cinema-going audience. But we should make clear at this point that the intellection of the sign may depend on certain levels of culture. Not only does an audience's level of

film culture enable the message to be more subtle, but the sign itself changes as the audience evolves: some signs go out of fashion, others are born, eagerly seized on by youthful audiences whose age establishes a kind of distinctive culture. Some directors (Vadim, Astruc) have stressed the need to renew the cinematic arsenal of signs with an eye to the rising generations: the boldness and foreshortening of a message may shock a cultivated man, if he is older, but satisfy an uneducated audience, if it is young. And it is not beyond the realms of possibility to imagine tests designed to determine thresholds of intellection of cinematic signs, as a function of their form and the sociological group receiving them.

Structurally, a sign is constituted by the bracketing of a signifier (or form) with a signified (or concept, in Saussure's language). These are, of course, analytic, operational realities. We have to see now what these two elements become in the filmic sign, it being understood that we will leave aside the study of the *oral* sign here, that is to say, the study of spoken narrative or dialogue.

[I] *Signifier.* The general substratum of the signifier includes sets, costume, landscapes, music and, to a certain degree, gestures. The moment of their appearance should be subjected to particular study. Signs are spread about the film with varying degrees of density. It is the opening of a film that clearly has the greatest density of signification. This is not only because, as we

have already noted, inaugurative phenomena are always aesthetically more important than others but also because the beginning of a film has an intense explanatory function. The exposition of a situation unknown to the viewer has to be effected as quickly as possible and the prior status of the characters and the relationships between them have to be *signified*. Paradoxically, in silent films, this exposition was entrusted to written captions; in sound film, on the other hand, the responsibility for conveying these signals is increasingly a matter for the visual dimension, the signs being grouped in the earliest images, during the titles—and sometimes even before them. The closing images may also see a renewed burst of such signs, insofar as they have to foreshadow what will happen when the film is over. The last image, in particular, may have genuine cognitive and premonitory value.

The spectatorial signifier has specific characteristics that we must point out.

[1] The signifier is *heterogeneous*, it may address itself to two different senses (sight and hearing). We must emphasize here that film music has a much more intellective role than is ordinarily believed. Very often, music is a genuine sign and conveys knowledge. In science-fiction films, a microphonic voice endowed with artificial resonance will function as the very sign of planetariness [*planétarité*], by a kind of distorting function reminiscent of the role of the mask in ancient theatre which was meant to dehumanize the actor.

A line of music made up of isolated, atonal, vibrato notes will signify expressly that the passage of film it accompanies is a *dream* episode, even though the images themselves are perfectly real (as in the evocation of the planned raid on the Deauville Casino in *Bob le Flambeur*). Generally, the heterogeneity of filmic signifiers achieves aesthetic value only if it is well controlled—richness isn't necessarily positive here. The aesthetic norms of film tend more towards sobriety and an economy of signifiers, unlike some arts which are based on the greatest possible accumulation of heterogeneous signifiers (such as opera, which by definition combines visual and auditory signifiers on a continuous basis).

[2] The signifier is *polyvalent*. That polyvalence is twofold: a signifier may express more than one signified (what in linguistics we call polysemy), and a signified may be expressed through more than one signifier (what we call synonymy).

Cases of polysemy are rare in the Western performing arts, unlike Eastern theatre where one signifier (for example, a 'scene lit by lamplight') can cover two signifieds ('bridge of light' or 'lake with water-lilies'). Eastern polysemy is possible because the sign is part of a genuine code of symbols of an extremely rigid kind, in which ambiguity of meaning is immediately limited by the context. But in our art, based essentially on the aspiration of the signifying relation to *naturalness*, polysemy is a source of disorder—it very quickly becomes

intolerable for an art that is constitutively *analogical*. With us, polysemy exists only as a residual trace (for example, the sound of a trumpet will indicate either the concept of paradise or of military victory), and only within a tried and tested rhetoric, the Western substitute for the ritualized code of the Chinese theatre.

On the other hand, synonymy is common, since that poses no threat to clarity of intellection. But in language the synonyms for a single word are only ever a potential reserve—they are not used together at the same time (except in Charles Péguy's style of writing, an experiment that hasn't been repeated). In films, it is standard for a single signified to be expressed through more than one signifier at once; we may even say it is synonymic density that defines a director's style. When the synonymy is too rich, it creates a certain vulgarity—the director heaps one signifier on another as though he has no trust in the viewer's intelligence. In fact, synonymy is only aesthetically valid if it is, so to speak, 'doctored'—the signified is rendered through a series of successive corrections and adjustments, none of which truly repeats any other. Some directors even practice a positive litotes of the signifier, the discreet nature of the sign serving as 'a nod and a wink' to the viewer who is 'in the know'.

[3] The signifier is *combinatorial*. Art can be defined here only as an elegant practice of merging or unifying signifiers—that is to say, of enumerating them gradually, without repetition and yet without losing sight

of the signified to be expressed. In short, there is a genuine syntax of signifiers. That syntax may follow a complex rhythm: for a single signified, some signifiers will be assigned steadily and continuously (for example, the film set), others almost instantaneously (for example, a gesture). The inversely proportional relation between the background signifiers and the gestural ones is entirely relative: in classical tragedy, the set is fixed from beginning to end of the drama, whereas in Chinese theatre it is extremely mobile. In ancient tragedy, the facial expressions of the actors are permanently set to the (as it were) eternal features of the mask, whereas in our cinema, even more than in our theatre, facial expressions are captured in their most fleeting aspects. It is film technique itself here (close-ups, tracking shots) that enables signifiers to be extremely mobile.

To close these brief remarks on the signifier, I shall provide as an example a combination of signs taken from Claude Chabrol's film *Le Beau Serge* concerned with indicating to the audience the social status of Serge's friend François. Here, very quickly, is how the visual lexicon of that status is established:

Signifieds	Signifiers
Young bourgeois	His clothing, in its opposition to that of the local peasants.
Emancipated	Dandyish details of clothing (his haircut, the form of his shirt

	collar, his waistcoat); specific features of adaptation of the urbanite's costume to the countryside (duffle coat, pullover).
Young	Features of clothing indicating adolescence (long, flowing scarf).
Intellectual	Large books in his bedroom. Reading glasses.
Former sanatorium patient	Swiss label on his case.
'Cinephile'	Reads *Les Cahiers du cinéma* over breakfast.

The art of the film director here doesn't consist only in finding the correct signifiers and in the elegant way they avoid rhetoric while nonetheless remaining intelligible. Together, they convey the idea that this young bourgeois intellectual is to a degree playing his own 'role' with that slight emphasis on the outward signs of that role which Sartre analysed in his famous passage on the waiter in *Being and Nothingness*.

[II] *The Signified*. Generally speaking, the signified has a conceptual character; it is an idea. It exists in the viewer's memory and the signifier merely actualizes it; it has a power to evoke the signified, not to define it. This, indeed, is why it isn't entirely exact to

postulate a relation of equivalence between signifier and signified in semiology. We aren't looking at an equality of a mathematical kind but, rather, a dynamic type of process.

The most important problem posed by the filmic signified is the following: *What, in the film, is signified?* In other words, precisely how far does semiology's legitimate role in film analysis extend? It is clear that a film isn't merely made up of signifieds. The essential function of film isn't of a cognitive order. In film, the signifieds are simply episodic, discontinuous elements— often marginal ones. We might venture the following definition of the filmic signified: *What is signified is everything that is outside the film and needs to be actualized in it.* Conversely, if a reality lies entirely within the course of the film and is, so to speak, invented and created by it, it cannot be something *signified.* For example, if the film enacts the story of an amorous encounter between two characters, that encounter is lived out in front of the viewer; there is no further need to convey this information, as we are in the order of expression, not of signalization. But if the encounter took place outside the film, either beforehand or between two sequences, the viewer can only be *apprised* of it through a precise process of signification and this expressly defines the semiological part of the filmic continuum. In other words, signification is never immanent to film but is transcendent to it. This is why signification is never central in a sequence, but

only ever marginal. The object of the sequence is epic in nature; it is its periphery that signifies. We may imagine purely epic sequences that are without signification and we may also imagine purely signifying sequences.

It follows from this that the signified is, most often, a state or condition of a character or of relations between characters, involving, for example, occupation, civil status, personality, nationality or marital status. Admittedly, it does happen that acts as well as states are signified. But, if we look more closely, what is signified in an act isn't its transitive element but merely its mode of being, the way it actually connects with a tradition or usage. For example, *dying* cannot be signified. It is the ethos of the act that is conveyed in a message: what will be signified is that the character dies 'classically' or dies as a 'gangster', etc., each of these modes being part of a particular—more or less rhetorical—lexicon.

I shall give some idea here of what a lexicon of filmic signifieds might look like, it being understood that what we have below is the most traditional version of this lexicon, a veritable vulgate of signs developed over the course of thousands of second-rate films:

Signifiers	*Signifieds*
Neon, doorman with cap, cigarette-girl in a tutu, streamers and paper hats, etc.	Pigalle-ness

Little square with street lights, cafes with terraces	Parisian-ness
Characters with close-cropped hair and centre partings, scars on cheeks, clicking of heels.	German-ness
Etc.	Etc.

––––––––

We should, in conclusion, indicate the specific, historic characteristics of the filmic sign. First, the relation between signified and signifier is essentially *analogical*; it is not arbitrary but motivated. Our art, and particularly our cinematographic art, sets a very small distance between signifier and signified. We are speaking of a narrowly analogical, not a symbolic, semiology—if a general is to be signified, then a general's uniform with all its details will be represented. Our filmic semiology isn't based on any sort of code; the viewer is regarded in principle as uncultivated and this semiology aims to provide him with a complete imitation of the signified (whereas our theatre has passed through symbolist phases). The filmmaker is condemned to reconstruct a *pseudo-physis*. He is free to use multiple signifiers, but not to be sparing with them or to reach for abstractions; he is entitled to use neither the symbol nor the sign (in the unmotivated sense of the term), but only the *analogon*. Then—and this is the opposite limitation on what is available to him—the filmmaker may only have recourse to rhetoric if he agrees to produce second-rate work. In our modern

art, rhetoric is discredited, unlike other arts which set great store by convention. I have referred on several occasions to Chinese theatre: it is well known that in that form the expression of feelings is strictly ritualized; there is, for example, a whole grammar of grief, which has to be observed with extreme precision. To signify that you are crying, you grip the end of your sleeve and, bowing your head, raise it to your eyes. In our part of the world, to signify that you are crying, you have to cry. Beneath an appearance of freedom and naturalness, our semiological art places the creative artist in a real tautological straitjacket within which invention is both obligatory and limited: the rejection of convention brings with it a no less draconian deference to *nature*. This is the paradox of our spectatorial semiology—it forces a constant pursuit of the new on us, without, however, permitting abstraction.

Review of
Civilisation de l'Image

Barthes contributed heavily to the early issues of *Communications*, founded in 1961 as the journal of the Centre for the Study of Mass Communications, a research centre formed within the École pratique des hautes études en sciences sociales on the initiative of Georges Friedmann. This and the next article are two of his four contributions to the journal's first number, the others being 'The Photographic Message', translated in Stephen Heath (ed.), *Image-Music-Text* (New York: Hill and Wang, 1977, pp. 15–31; reprinted in: Susan Sontag (ed.), *A Barthes Reader*, New York: Hill and Wang, 1982, pp. 194–210) and a review of 'Les études de motivation' by J. Marcus-Steiff (*Communications* 1, pp. 207–8).

The article is a review of a thematic number of the Catholic academic journal *Recherches et débats du Centre catholique des intellectuels français* 33, December 1960 (Paris: Fayard) entitled *Civilisation de l'image*. The Centre catholique des intellectuels français (CCIF), founded as an underground organization in 1941, played a role in post-war debates on the future of French society and religion and, in particular, in the preparation of the Second Vatican Council. It was formally dissolved in 1977.

Oeuvres complètes, Volume 1, pp. 1137–9

The aim of this collection of essays is a deliberately modest one: the only issue, for each of its contributors, is to take stock of the new phenomenon, specific to our century, represented by the extraordinary advancement of the image in our lives as modern human beings. The work has, therefore, no scientific or methodological pretensions; at no point will one find in it any psychology or sociology of the image, but only the reaction of people who are trying to think as humanists about a subject that is at once technical and 'human'. The image is treated either in terms of its nature (film, strip cartoons, religious imagery, photography, television) or in its relationship to different disciplines (history, ethnology, theology). The contributions are unequal. They bring little in the way of information and are mainly statements of ethical or spiritual positions. The pieces that interested me most were those by Georges Gusdorf ('Thoughts on the Civilization of the Image') and Father André-Vincent ('Towards a Theology of the Image').

But precisely because it brings together a certain number of spontaneous reflections on an object that is, as it were, new—whose mass distribution is, at least, unprecedented—this collection of articles provides excellent evidence of attitudes towards that object, akin to what the distribution of written material must have prompted in its own day, though the attitudes laid out here are openly those of an ideologically committed group of authors. All things considered, there is currently a certain 'mythology' of the image, which is excellently reflected in the Catholic intellectuals' collection.

The first myth prompted by the image—and by a long way the most insistent—is that of the conflict between technology and man, between material progress and spiritual values. Is the modern image spiritually good or bad? The authors ponder this, and their perplexity is clear to see. On the one hand, the diffusion of images is part of the modern world and a product of technical society: hence, to condemn the image is apparently to condemn modernity. On the other hand, however, not only is the image a vehicle for drives, affects, irrational and instinctual forces (at least this is the assumption) but, most importantly, it spreads in an uncontrolled way, which cannot but trouble any organized ideology. Hence, the Catholics contributing to this volume are divided (at least one senses this as one reads it) between a certain wariness of the promotion of the image, insofar as it is 'new', and a very great desire to understand the irreversible forward

march of their century. The outcome of the conflict remains, in fact, purely verbal: each writer argues for a nuanced judgement, without the synthesis of the 'modern' and the 'eternal' being achieved (assuming we accept these terms of the debate). Arriving at a 'happy medium' is never a truly dialectical operation.

Another temptation, which surfaces here and there, is to polarize human communication radically and regard articulated language, speech, as the instrument of the intellect, of discursive, abstract reason, and the image, by contrast, as the natural vehicle of affects, myths and pathos—in short, of 'feeling'. This antithesis makes it possible to conclude that humanity is currently regressing towards the irrational (or childhood), a regression which can, in fact, be turned around at the eleventh hour, making the image a privileged form of communication with the sacred. In the current state of analysis, this division of 'roles' between images and words is absolutely arbitrary. On the one hand, the 'affective' power of the image is still unknown, which means that, for the time being, it can and must be doubted. The affectivity of images remains a myth that only too clearly serves a particular interest: it is by postulating this affectivity, without ever questioning it, that forms of censorship become established and triumph. To question the affective nature of images would be to question censorship itself; we can well understand why society is reluctant to discuss the 'effects' of images—it needs them. And, on the

other hand, it is even less possible to reduce language to pure *logos*. Words bamboozle and intimidate; they give us pain and fuel our dreaming; they trigger infinite affective and traumatic processes. In truth, the notions of affect and intellect are themselves suspect. It is, then, all the more dangerous to reserve special languages for them, for what defines a language isn't what it says but the way it says it.

A third and final remark: some of the authors in this volume have clearly perceived that there is 'meaning' in images, that they are 'signs' or 'language'. These words have a happy prestige today. They enable one to suggest that one's intention is to react against a purely aesthetic or purely mechanical interpretation of cultural objects. Unfortunately, such expressions generally remain metaphorical: they are turns of phrase, options one takes without ever subsequently grounding them in argument. Now, any 'signification' (and, all the more so, any 'language') involves a very precise structure. We cannot merely say that something 'signifies' without entering into a technics of meaning or, in other words, a semantics, which is perhaps, as has been said elsewhere, something that runs much more true to type than the signifieds themselves (moreover, there is much talk here of signification but none of signifiers and signifieds, which is quite an achievement). In short, to draw on the idea of *sign* without going on to refer to the structure that constitutes it is either to go too far or not to go far enough.

These remarks, it will be clear, are chiefly of a 'mythological' order; they are not intended to impugn the sincerity of a work that has fulfilled its initial project, since what was at issue for those involved in that project was simply to arrive at an awareness, as— committed—witnesses to their age, of the new cultural object that seems to be putting its stamp upon it.

Visual Information

This second article from *Communications* 1 is a critical account of the Prima Conferenza Internazionale di Informazione Visiva (First International Conference on Visual Information), held at Milan on 9–12 July 1961 under the auspices of the Istituto Gemelli-Musatti.

Oeuvres complètes, **Volume 1, pp. 1140–3**

We live surrounded by images, steeped in them, and yet we still know hardly anything about the image: What is it? What does it signify? How does it act? What does it communicate? What are its likely effects—and its unimaginable effects? Does the image affect pure man, anthropological man or, rather, socialized man, a man already marked by his class, his country, his culture? In short, is the image a thing of psychophysiology or of sociology? And if it belongs to both, what is the dialectic between them? Convened at the prompting of the Istituto per lo studio sperimentale di problemi sociali con ricerche filmologiche ed altre tecniche, the Milan Conference, though neither intending nor able to answer all these questions, at least established their scientific importance in a manner beyond dispute. This was, in fact, a conference, not a congress, by which I mean that the participants were not faced with established findings but, rather, engaged, as they looked to the future, in drawing up

together an inventory of all the problems raised by the enormous advancement of visual information in the contemporary world and establishing an international plan of research.

The conference, at which Italian and French participants were in the great majority, divided into working groups which were (and I quote here from memory) Neurophysiology, Psychology, Sociology, Education, the Press and the History of the Image. Each group established the list of desirable research projects in its own particular field, attempting as far as possible to assign them an order of priority. These individual lists were meant to provide the basis for a huge interdisciplinary comparative exercise which was the main object of the conference but, in the event, time proved too short. Each group had to confine itself to communicating its research plan to the neighbouring group, without genuine discussion between the different specialists being possible. The conference did, however, end with a common resolution, resolving to create an International Council for Scientific Research on Visual Information (CIRSIV) to coordinate research in the field of visual information.

It would seem that the success of the conference lies much less in its results than in the profusion of questions raised and the enormous curiosity to which it attests. On an entirely novel subject, which no particular science has yet laid hold of, each researcher was able, so to speak, to give vent freely to his plans,

problems and biases. The conference didn't coordinate anything, but it at least gave voice to the questions that modern man finds burgeoning within him in respect of a mode of communication whose mass use is one of the great new features of the century. In that sense, despite the disordered nature of its concerns, or because of it, the conference displayed a genuine scientific spirit, insofar as that spirit consists in interrogating forcefully—if not, indeed, naively—the generally accepted facts of the world we live in.

While recognizing this, we should nonetheless say that the work of the conference sometimes involved certain orientations, if not indeed assumptions, that are open to debate.

To begin with, the expression *visual information* seems most often to have been a euphemism intended to refer almost exclusively to cinema. Most of the working groups confined themselves to studying film, assigning television an incidental status and regarding press photography as a mere derivative of the filmic image. This is a dangerous assumption. For years, one of the conference's prime movers Gilbert Cohen-Séat rightly campaigned to have the specific character of filmic perception recognized, proposing that the study of the moving image be elevated to the status of an independent, grown-up science—filmology. But if cinematic activity is special—which is probably the case—then, logically, the other forms of image are also. The television image and the still image have

their own specific structure, and it would be a methodological error to regard them as mere derivatives of cinema. The current imperialist attitude of cinema to the other techniques for conveying visual information can be understood historically; it cannot be justified epistemologically.

A second prejudice, which seems to have dominated in many of the working groups, is the constant reduction of the problem of visual information to the problem of its *effects*. That is, of course, a valid question and there is much research to be done on it. But we should at least be aware that this is a very particular (and should I say already outdated?) way of posing the problem. Social phenomena can be conceived in causal terms, but also in terms of signification. The image can transform the psyche. But it can also signify it. To a sociology or physiology of visual information we should therefore add a semantics of images.

This epistemological broadening or renewal is all the more desirable as the quest for 'effects' seems rather disappointing. We know from the latest studies that the sociology of mass communications currently regards information as only rarely a cause of change: mostly, it confirms beliefs, dispositions, feelings and ideologies that are already given by the social, economic or cultural state of the audience analysed. Simply put, all visual information research, if it were truly free, would have to admit that the effects of that information are thoroughly problematical and we shall

perhaps have to recognize one day that they are weak or non-existent. This is a crucial issue, since if it turned out, for example, that the image affects the psyche less or in a different way than was thought, all the common sense arguments for censorship would be undermined.

Concentrating mainly on processes and effects, the conference seems to have taken little interest in the contents of visual information. However, the image necessarily conveys *something other* than itself and that *something other* cannot be unrelated to the society that produces and consumes it. It would perhaps have been better if the conference had set out in advance inventories of ideas and themes more clearly than it did. That would have made it possible to resituate visual information within the framework of a real history of the present world. Clearly, the conference handed over the task of historical reflection on the image to an autonomous working group, but that seems to have served largely as a kind of exorcism, absolving the other groups of the need to connect the object of their study with the deep realities of the society that is in the making.

Lastly, the number of questions arising—indeed, their profusion—sometimes led to the working groups being unaware of some already established findings, of work that has already been published and questions that have already been settled. At times, the discovery of new problems was confidently proclaimed when they were, in fact, old ones. And solutions were called

for that had already been found. This was no doubt down to two circumstances. On the one hand, as a scientific object, visual information must draw on very diverse disciplines which are often unaware of one another and, as has been said, there was insufficient time for essential coordination which we must hope will be the aim of the new Scientific Committee created by the conference. On the other hand, in its legitimate desire to confront a broad group of disciplines with one another, the conference brought together participants of very varied degrees of specialization, with the result that the research proposals that were eventually assigned in a chaotic fashion are not all equally imperative. Had the conference been scientifically more homogeneous, it could have sorted out the questions to be resolved more rigorously and prepared the ground for the work of individual researchers more effectively. For, ultimately, it is on each of them that the knowledge we shall be able to have of the world of images depends.

Dandyism
and Fashion

Oeuvres complètes, Volume 2, pp. 27–31

The *United States Lines Paris Review* was a publication distributed free of charge by the prestigious United States Lines shipping company. The magazine was founded by the French abstract painter Georges Mathieu while working as a public relations officer for the company. Mathieu, who is well known for having introduced a number of modern American artists into France, was editor-in-chief between 1953 and 1963.

The following article was Barthes's contribution to a special number on dandyism in 1962. His more extended work on clothing and fashion, *Système de la mode,* was not published until April 1967 and would not appear in English translation for a further 16 years (*The Fashion System.* New York: Farrar, Straus and Giroux, 1983).

For centuries there were as many types of clothing as social classes. Each social condition had its costume and nothing stood in the way of the outfit functioning as a genuine sign, since the disparity between social strata was itself regarded as natural. While, on the one hand, then, clothing was subject to an entirely conventional code, on the other, that code referred back to a natural—or, more precisely—a divine order. To change costume was to change both being and class, for the two things were inseparable. Thus, in Marivaux's comedies, for example, we see the game of love coincide both with mistaken identity, permutations of social standing and exchanges of costume.[1] There was in those days a genuine grammar of clothing that could not be transgressed without offending not merely against the dictates of taste but also against the deep order of the world: how many twists and turns of the plots of our classical literature depend on the role of clothing as an outright indicator of identity!

1 One of Marivaux's major comedies, first performed in January 1730, is called *Le jeu de l'amour et du hasard* (The Game of Love and Chance). [Trans.]

We know that in the aftermath of the [French] Revolution, male clothing underwent a thorough transformation, not only in its form (deriving, in the main, from the Quaker model) but also in its spirit. The idea of democracy produced a theoretically uniform style of clothing, no longer subject to the overt requirements of *show* but to those of work and equality. Modern clothing (for our male suit of clothes is essentially that of the nineteenth century) is, in theory, practical and dignified: it has to be adapted to any work situation (provided such work isn't manual); and, by its austerity, or at least its sobriety, it must display that moral cant which characterized the bourgeoisie of the last century.

However, the separation of social classes wasn't actually eliminated in any sense: defeated politically, the aristocrats still had powerful prestige, though that was confined now to lifestyle; and the bourgeois, for their part, had to defend themselves not against the workers (whose costume remained distinct) but against the rise of the middle classes. So clothing had, as it were, to cheat with the theoretical uniformity that the Revolution and First Empire had given it and, within what was now a universal type of clothing, a number of formal differences had to be achieved that could show the opposition between social classes.

It was at this point that we saw the emergence of a new aesthetic category in clothing that had a great future ahead of it: the category of *detail* (you only

have to open a fashion magazine to see that women's clothing still makes abundant use of this). Since the basic type of male clothing could no longer be changed without infringing the democratic, work-oriented principle, the entire distinctive function of male costume was vested in *detail* (the 'merest hint', the 'certain something', the 'style')—from that point, the way a tie was knotted, the material of a shirt, the buttons of a waistcoat or the buckle of a shoe sufficed to mark the subtlest social differences. At the same time, superiority of status, which couldn't now be flaunted on account of the democratic principle, was concealed and sublimated in a new value—*taste* or, more precisely, since the word is fittingly ambiguous, *distinction*.

A distinguished man is one who marks himself off from the common herd using resources that are limited in quantity but extremely powerful in terms, as it were, of their energy. Since, on the one hand, he is concerned to have recognition only from his fellows and since, on the other, that recognition depends largely on details, we may say that the man of distinction adds a number of *discreet* (and *discrete*) signs to the uniform of the century—signs which are no longer the spectacular marks of an openly declared status but simple signs of group collusion. Distinction actually takes the signaletics of clothing down a semi-clandestine route, since, on the one hand, the group it is addressing is small and, on the other, the requisite signs are few in number and difficult to perceive without a certain knowledge of the new language of clothing.

The dandy (to speak only of his clothing here, since it is well known that dandyism is not merely a particular attitude towards dress) is a man who has decided to radicalize the style of dress of the man of distinction by subjecting it to an absolute logic. On the one hand, he pushes distinction to an even further level: its essence is no longer merely social for him but metaphysical. The dandy isn't at all concerned to set upper class against lower; for him the only distinction is between the individual and the common herd. Furthermore, the individual for him isn't a general idea but himself, cleansed of any comparative aspect, so that ultimately, like Narcissus, his own clothing is addressed as a message to himself alone. Moreover, he professes that his essence, like that of the gods, may be entirely present in the '(*mere*) *nothing*': the vestimentary 'detail' isn't even a concrete object here, however tiny it may be, but an—often subtly roundabout—way of ruining the article of clothing, of 'deforming' it and withdrawing it wholly from the realm of value as soon as the value concerned becomes a shared one. Having a brand-new suit worn by his valet or wetting his gloves so that they take on perfectly the shape of his hands are actions attesting to the idea—an idea no longer merely selective but profoundly creative—that thought has to be given to the *effects* of a form, that an article of clothing isn't just a produced item but a treated *object*.

Dandyism isn't only an ethic, then, (on which much has been written since Baudelaire and Barbey

d'Aurevilly) but also a technique. It is the combination of the two that makes the dandy, and it is clearly the latter that underwrites the former, as in all the *ascetic* philosophies (of the Hindu type, for example) in which a type of physical behaviour provides a pathway to a form of thought. And, as the form of thought in this case consists in an absolutely singular vision of oneself, the dandy is condemned constantly to invent infinitely new distinctive features: at times he draws on wealth to mark himself off from the poor; at others he seeks out a worn look to mark himself off from the rich. It is precisely the function of the 'detail' to allow the dandy to escape the masses and stay out of their grasp—his singularity is absolute in essence but restricted in substance, for he must never give in to eccentricity which is an eminently imitable form.

'Detail' made it possible for his clothing to be indefinitely 'other'. The ways of wearing an article of clothing are, in fact, limited and, if certain details of manufacture do not come into play, one very quickly runs out of ways of renewing one's costume. This is what happened when male clothing became squarely industrial. Deprived of any recourse to hand-made clothing, the dandy had to give up on the idea of an absolutely singular costume, for as soon as a form is standardized—even as luxury apparel—it cannot ever be unique again. Thus ready-to-wear clothing dealt the first lethal blow to dandyism. But, more subtly, what wrecked it once and for all was probably the

emergence of 'original' boutiques. These boutiques deal in clothes and accessories that do not conform to mass norms. But since that non-conformity is achieved by a business—albeit a high-end luxury business—it becomes normative itself: in buying a shirt, a tie or cuff-links from X or Z, one is *conforming* to a certain style, abdicating any personal (one might say, narcissistic) invention of singularity. Yet, it was a fundamental requirement of dandyism to be creative. The dandy *conceived* his outfit in exactly the way a modern artist conceives a composition from available materials (as, for example, with a collage). In other words, a dandy absolutely could not *buy* his form of dress. Reduced to a freedom of purchase (and not of creation), dandyism could only suffocate and die. Buying the latest Italian shoes or English tweed is an eminently vulgar act, insofar as it is conformity to Fashion.

Fashion is actually the collective imitation of a regular novelty; even under cover of expressing an individuality or, as they say today, a 'personality', it is essentially a mass phenomenon in which sociologists have taken a keen interest because it represents such a prime example of a pure dialectic between individual and collectivity. And fashion has, in fact, become everyone's business today, as is attested by the extraordinary development of the specialist women's magazines. Fashion is an institution and it is no longer possible to believe that it *affords distinction*. Only the notion of the 'unfashionable' confers distinction; in

other words, from a mass standpoint, Fashion is only ever perceived through its opposite. Fashion is the health or the morality of which the unfashionable is merely the sickness or perversion.

So we have seen the following paradox: Fashion has exterminated all *conscious* singularity of clothing by tyrannically taking charge of its institutional singularity. It isn't clothing itself that has become bureaucratized (as, for example, in those societies without fashion) but, more subtly, its project of achieving singularity. Injecting a little dandyism into the whole of contemporary clothing through Fashion was inevitably lethal to dandyism itself, since dandyism was, in its essence, condemned either to be radical or to disappear. So it wasn't the general socialization of the world (as one might imagine in a society with rigorously uniform clothing, such as current Chinese society) that killed dandyism but the intervention of an intermediate power between the absolute individual and the total mass: it fell to Fashion to, as it were, spirit dandyism away, to neutralize it; modern, democratic society established Fashion as a sort of balancing institution whose role was to achieve an automatic equilibrium between the demand for singularity and everyone's right to satisfy that demand. That is obviously a contradiction in terms, and society was able to make it viable only by subjecting innovation in clothing to a strictly regular timescale—sufficiently slow that it is possible to submit oneself to it, but sufficiently quick

to speed up purchasing rhythms and re-establish distinctions of fortune between men.

Where women's clothing is concerned, no doubt the high number of elements (*units*, one might say) that make it up still permits of a wide range of combinations and hence a genuine individuation of outfits But, without speaking of the (probably homosexual and narcissistic) psychological traits that made it an essentially male phenomenon, dandyism was only possible in that historically ephemeral period when clothing was uniform in its type and variable in its details. More slow-moving and less radical than women's fashion, male fashion has nonetheless run the full gamut of variations in detail without, however, having tampered in any way with the basic type of clothing for many years. Hence it has deprived dandyism of both its limits and its main driver—it was indeed Fashion that killed dandyism.

The Civilization
of the Image

This review of 'La civiltà dell'immagine', *Almanacco Letteriaro Bompiani* (Milan, 1963) was Barthes's sole contribution to the third issue of *Communications* in 1964. He casts doubt here on the validity of the expression as a characterization of contemporary civilization, as he would later do in the better-known essay 'Rhétorique de l'image' in *Communications* 4 (1964), translated as 'Rhetoric of the Image' in Stephen Heath (ed.), *Image-Music-Text* (New York: Hill and Wang, 1977, pp. 32–51).

Oeuvres complètes, Volume 2, pp. 564–6

Two years ago *Communications* reviewed a collective work published by the Centre catholique des intellectuels français entitled *Civilisation de l'image*.[1] Here is the same title again, this time applied by the Italian publishers Bompiani to their Almanac for 1963. The fact that this expression enjoys such currency merely encapsulates quite naturally the very sharp awareness we have (to the point of its being self-evident) that images are more or less *all-pervasive* in our society. But, like every self-evident point, doubt very quickly arises about it or, at least, it seems to require some qualification. Before we can state that our twentieth century is indeed a civilization of the image, we would need at least two types of knowledge. First, what we might term an 'ontology' of the image: What is the image? How many kinds are there? How are

1 See above, pp. 35–40

they to be classified? Where do they begin, and where do they end? The word itself is very elusive, referring us back and forth ceaselessly in a complicated way to the product of a physical perception and to a mental representation—that is to say, at times to an *imagery* and at others to an *imaginary*. It appears very difficult to *stop at* the image, perhaps because of its de-realizing function which is admirably brought out by Sartre in the only book so far to contain a definition and classification of images.[2] The difficulty commonly experienced in finding a consistent bibliography under the heading 'Image' in the methodical works on the subject provides empirical evidence of this state of disarray.

To this definitional uncertainty can be added a historical failing. When we state that we live today in a civilization of the image, we necessarily suppose that earlier civilizations used little in the way of iconic communication. Yet, though we have no comprehensive study of the question, we may wonder whether we are not tending to misjudge or underestimate the role of that communication in past civilizations, forgetting that images played a profound role in the daily lives of the people of yesteryear (stained-glass windows, paintings, almanacs, illustrated books). In fact, the historical opposition isn't between writing and images (our civilization isn't illiterate and the civilization of

2 Jean-Paul Sartre, *L'Imaginaire* (Paris: Gallimard, 1948), pp. 247–8.

yesteryear was so in part) but, rather, between a purely iconic and a mixed (image and language) communication which is that of today. The very acute sense that we have now of a 'rise' of images leads us to forget that, in this civilization of the image, the image is never, as it were, wordless (photographs with captions, advertisements with verbal messages, talking cinema, *fumetti*). This prompts the thought that the study of this modern world of images—which hasn't really been undertaken yet —is in danger of being distorted in advance if we do not work directly on an original object that is neither just image or language but image coupled with language in a form we might term logo-iconic communication.

It wasn't the role of the *Almanacco Bompiani*, an instrument of intelligent popularization, to present a thorough problematization of the modern image or a genuine survey of modern images but, rather, to show how very different minds, inspired variously by aesthetics, sociology, psychoanalysis, Marxism or structuralism, can initiate thinking on types of images that are invisible because they are taken for granted—images from the mythic symbol (the star, the disc, the ring, the spiral) to advertising images, American-style comics, photo-romances and album covers. But, first and foremost, some excellent iconographic material is to be found in this collection. Now, for any (future) study of the image, the collation of materials is very important, insofar as it is precise and methodical in its scope. The

analysis of images can only be differential, and it is crucial to be able easily to compare series of iconic forms that are, following the paradigmatic principle, both similar and dissimilar. At the beginning of the almanac, a very precious collection of pictograms is to be found (trademarks, publishers' logos, typographical and meteorological signs, alchemical symbols, etc.) on which the semiological novice could practise, attempting to reconstruct formal paradigms of lines. We know that the letters of the alphabet can themselves be subjected to a paradigmatic analysis: between E and F, for example, there is a common element—the graphic sign F (it forms the 'basis of comparison'). In this way, we could reconstruct the differential morphology of the main graphic signs of humanity. And although the 'full' image is no doubt of a quite other nature than the schema or letter, it would certainly be of interest to clarify the semantic structure of all these pictograms once and for all. It would be an excellent introduction to the study of 'continuous' images (such as photographs or drawings), since, though it is decomposable (that is the analytical advantage of it), the pictogram already presents that analogical relation—from signified to signifier—which seems to be the distinctive feature that enables a category that can be called 'Images' to be recognized within the general universe of signifiers. By the excellence of the materials it brings together, the *Almanacco Bompiani* helps us to gain a sense of these methodological problems.

Preface
(*Emmanuel Pereire Exhibition Catalogue*)

Oeuvres complètes, Volume 2, pp. 722–3

The following piece was written as the preface to the catalogue of Emmanuel Pereire's exhibition at the Galerie Knoedler, Paris in November 1965, which was largely responsible for bringing him to public attention. A series of paintings depicting a telephone, an alarm-clock, a typewriter and a large insect was particularly prominent in that exhibition.

Barthes added the following note to his text: 'E.P. born in Paris in 1930. Worked with Fernand Léger from 1947–1949. Stays in Florence, 1949–1951 (studies different techniques, including fresco). Tokyo Biennale 1964. First individual exhibition.' To this we may add that there was a small exhibition of his work at MoMA in New York in 1972 (*Projects*: *Emmanuel Pereire*) and that he exhibited paintings at that gallery's reopening in 1984. The Fondation Cartier in Paris granted him an important retrospective in 1987 (*Emmanuel Pereire*, P*eintures 1983–1987*). Pereire died in 1992.

On no account did Flaubert want his books to be illustrated since, as he saw it, everything given definite shape by drawing loses its generality. Perhaps he wouldn't have talked that way if he had met Emmanuel Pereire. We can go much further and say that, contrary to what Flaubert thought, whereas literature has the greatest of difficulty speaking of subjects without predicates and nouns without adjectives, painting is very good at presenting us with objects without determination. Take the objects painted by Emmanuel Pereire. No one in the world can take this sea, this city wall or this dragonfly and make it his dream or his property. Pereire doesn't 'describe' what he paints: it is *there*—issuing from an ageless age through a kind of optical *jeté* which at times invades the canvas from the side, at others decentres it. There is nothing here of the pedestal of still lives—nothing of their setting, their background.

We always believe the essence of something is to be found in its reduced form. However, it is by a certain *hugeness* that Emmanuel Pereire gets to that essence. Only, that hugeness isn't indiscriminate; it is apportioned in accordance with an implacable spectroscopy

of the object. It is a found hugeness: in one case, it takes the form of the simple sphere of the pumpkin. In another, the keys of a typewriter, an object which normally evokes intricate machinery and hence finesse, are like the teeth of large animals, its levers as thick as bones, the space bar as hostile as a crossed arm, and the entire machine becomes a giant tower of Babel (which the poor writer can only master by being strong and fearless). Lastly, in the family of insects, from mantis to cockroach, the hugeness is in the feet, rods, levers and spikes by which these animals are, in fact, defined, since scientifically they are merely *articulated* invertebrates. If it is true, as Valéry suggested, that Nature is *the given*, then there is a certain naturalism in the work of Emmanuel Pereire: his flies are as much 'a thing of dreams'—that is to say, they are as true—as the flea seen under the microscope which the Encyclopaedists reproduced in their plates. Similarly, in his series (which are not variations on a theme but the progressive orientation of a diversity thrown up both by nature and the painter), Pereire shows that finesse, detail, symmetry and order—in a word, description (always an Apollonian value)—aren't necessary for the clarity of the object.

There remains man, and it is impossible to represent *him* as a pure subject. He either *is* or *is doing* something (and if he isn't doing anything, then he *is* all the more). Emmanuel Pereire's *characters* (there's no other word for these waves of men, that is to say,

these abundances of humanity) are all actors: they swim, carry bundles, hold their hands out to feel the rain, write (or do not), but the recognition we can gain of them is deferred indefinitely, since we can never bend them towards any adjective—they are only ever what they do. Now, this is a very ancient form of representation— or a very modern one. At all events, it is rare. Like the tales our forefathers told—or like some very modern novels—Emmanuel Pereire's painting doesn't characterize man but sets out his doings.

There is a strand within modern art (we may think of literature again here) that strives to make objects but not the meaning they are all too inclined to radiate: in short, the artists assume the (highly technical) task of *not inferring*. This *no* to meaning, which is actually the opposite of non-meaning, cannot but have a violent impact, so much do human beings find signs, of whatever kind, reassuring. The essence of a thing is always aggressive. This means that Emmanuel Pereire's art can never be a peaceful affair; in him, extreme aggressiveness comes together with extreme intellectuality, which is right, because strength is always abstract—a natural trajectory unites primitiveness and intelligence. Emmanuel Pereire provides us with a very sound summary of that trajectory: it is both a very early and a very evolved thing; it is given, constructed, then given again—in short, offered to what we might call our anthropological intelligence. We find ourselves dreaming here (for this isn't only about the painter) of

a certain future for art, an art busy capturing universal aggression in such a way as to create for us a very good and humane society in which we could live in peace with only the war between our fantasies before us.

The
Marthe Arnould
Exhibition

This short text was the preface to the cata-
logue of the exhibition curated by French
sculptor and art historian Marthe Arnould
entitled *Image et signification dans l'exem-
ple des hiéroglyphes égyptiens* (Image and
Meaning in Egyptian Hieroglyphs) at Galerie
Domec, 33 rue Saint-Placide, Paris, from 21
January to 19 February 1966.

*Oeuvres
complètes,*
**Volume 2,
pp. 805**

We are well aware today that what separates human beings from animals isn't communication (animals communicate very well) but signification. And our century has explored this major anthropological fact with a very distinctive passion.

For lovers of signs, nothing is more exciting than hieroglyphic writing; they find in it something like a perfect allegory of what they have learnt and the problems that remain, a deep (and at times dizzying) representation of the question they are constantly asking themselves: How do human beings make meaning? How does meaning come to human beings?

There are essentially two ways to institute a sign: by bringing its two terms—signifier and signified—together by way of an analogical image (an *icon*, as the semiologists say); or by establishing a purely formal connection between a group of sounds and a concept (this, properly speaking, is the *sign*). Hieroglyphic writing, at times figurative, at times phonetic, combines the two systems.

Admittedly, this is not as rare a mix as we might think. Spoken language contains many analogical elements in the way it is derived or composed, and in the sounds themselves, whose symbolism we are beginning to rediscover. Every conventional system is permeated by analogies and every system of images is permeated by conventions. There is no half-way complex meaning without that balance. But alone perhaps of all signifying systems, hieroglyphic writing presents, directly and with such a degree of control, the profound ambiguity of the figure and the sign, which is the very ambiguity of 'life' and 'thought'.

Thus, by proposing to cast light on the secrets of hieroglyphic writing, Marthe Arnould is not merely contributing to a worthwhile teaching project or aesthetic endeavour, she is giving us access to the very technics of meaning, which is nothing less than the way human beings think the world.

Visualization
and Language

(An Interview by Philippe Pilard)

Oeuvres complètes, Volume 2, pp. 876–81

Barthes was interviewed early in 1966 by the schools television programme–maker Philippe Pilard, who had previously (with Michel Tardy) interviewed him on the subject of 'semiology and cinema'. The earlier interview, published in *Image et Son* of July 1964, is available in English in Roland Barthes, *The Grain of the Voice: Interviews, 1962–1980* (Berkeley: University of California Press, 1991), pp. 30–7.

The present interview—on visualization and language—was published in *Bulletin de la radio-télévision scolaire* 40 (28 January–12 March 1966), pp. 25–7, in the section entitled 'Problems of Visualization' which was highlighted on the front cover of the magazine. Other contributors to this special section included Jacques Bertin of the École pratique des hautes Études, a leading cartographer and expert on information visualization, and Michel Tardy, then a lecturer in educational psychology at the University of Strasbourg.

PHILIPPE PILARD. When we want to study the problems posed by what's termed 'visualization', we find it difficult not to approach them by way of the image (whether it's a still image, as in the photograph, or an animated one like the cinematic or televisual image). And the term 'language' [*langage*] immediately makes its appearance: cinematic language, photographic language, televisual language, etc. What are your thoughts on this?

ROLAND BARTHES. The word *language* is often used metaphorically for any kind of communication or—and this is a more serious problem—for any kind of expression.[1] For example, when we speak of *cinematic language*, we are in fact referring to cinematic expression. Technically speaking, *language* is something very precise: in the sign system

1 On this point, see Dina Dreyfus, 'Image et langage', *Bulletin de la radio-télévision scolaire* 38: 21–3.

that makes up our articulated language, signs are, if I may put it this way, twice divided—a first time into *words*, a second time into *sounds* (and letters). At the level of the word, the relation uniting signified and signifier is an unmotivated relation; for example, when we say *ox*, the sound itself has no analogical relation to what we might call the *psychical image* of the ox. You can see the truth of this in the way the sound used changes from one language to another. The second articulation—of the phonemes—functions by (binary) oppositions that are finite in number. This is why our articulated language is described as being a digital code because it functions by digits, as electronic machines do. It's this double articulation that's the foundation of articulated language.[2]

Alongside our double-articulation-based system that is language, there are other systems of communication in which the relationship between *signified* and *signifier* is analogical. This is the case, for example, with photography[3] (in this particular case, that relationship is very strong, very 'verist',

2 On the 'double articulation of language', see André Martinet, *Elements of General Linguistics* (London: Faber & Faber, 1964). See also Ferdinand de Saussure, *Course in General Linguistics* (Glasgow: Fontana/Collins, 1977).

3 See Roland Barthes, 'Le message photographique', *Communications* 1 (1961): 127–38.

as we might say), with diagrams, such as those of the Highway Code, and with certain drawings produced for teaching purposes. We can't speak, then, of *language* to describe a sign-system without double articulation in which the *signifier/signified* relation is analogical. What has to be understood is that, by dint of the different nature of the sign (analogical or arbitrary) in each of the two systems, each system, each code refers to a different mental functioning and apprehension and *découpage* of reality.

One might say that these two codes have entirely different phenomenologies or modes of consumption.

PILARD. What is curious where writing as representation of articulated language is concerned is that the first known writing systems are pictogrammatic and hence analogical . . .

BARTHES. Writing does first appear as a system of visualization of articulated language. Without wanting to go into the detail of the history of writing, it may be interesting to consider the hieroglyphic system of the Egyptians.

At a certain moment in the history of that writing, there was in existence a mixture of the two codes we were speaking of. On the one hand, there were little, purely analogical drawings—for example, the image of a man pouring water over his head '*signified*' *purity*—and it was, therefore, an iconic,

analogical code. On the other hand, that same drawing could be given an arbitrary value and refer to sounds, with the analogical relation disappearing and giving way to an unmotivated relation. That is, in fact, what makes that hieroglyphic system so difficult and also what lends it its appeal and its depth.

PILARD. Don't you think that the desire to grant the status of language to visualization procedures or to iconic means of expression represents an intention to enhance the status of those systems which are regarded as somewhat *suspect* on account of their power to create an immediate impact on those who consume them?

BARTHES. No doubt. The image, as sign, as element in a system of communication, has a substantial *impact value*. Attempts have been made to study the power of this impact (Cohen-Séat has carried out such a study with respect to cinema).[4] But we still know very little about the semantic yield of images.[5] All we can say, as of now, is that we need

4 See Gilbert Cohen-Séat, *Essai sur les principes d'une philosophie du cinéma* (Paris : PUF, 1964); *Problèmes du cinéma et de l'information visuelle* (Paris: PUF, 1961).

5 On cinema, see also Roland Barthes, 'The Problem of Signification in Cinema' (pp. 21–34); M. Delahaye and J. Rivette, 'Entretien avec R. Barthes', *Cahiers du cinéma* 147; Philippe Pilard and Michel Tardy, 'Entretien

to be very cautious—as a sign, the image has one very great weakness or, let us say, difficulty, which lies in its polysemic character. An image *gives out* different meanings and we don't always know how to handle them. Moreover, this phenomenon of *polysemy* also exists in articulated language, and is one of the main themes of current linguistic research. But the fact remains that, in the case of language, polysemy is considerably reduced by context, by the presence of other signs which direct the choice and the intellection of the reader or hearer. For its part, the image presents itself in a general rather than a discontinuous way and it is, to that extent, quite difficult to determine its *context*. Even in the case of contiguous iconic or temporal iconic *sequences* (such as photographs placed side by side in the former case[6] or cinema or television, for example, in the latter), we don't clearly understand the associative syntax that pertains between images and, as a consequence, it isn't yet possible to determine or assess the *power to resolve ambiguities* which the iconic context may

avec R. Barthes', *Image et son* 175; Christian Metz, article from *Communications* 5 [This reference is vague, since Metz had three articles in that number of the journal (Trans.)]. See also 'Recherches sémiologiques', *Communication*, 4 (1964).

6 See Michel Tardy, 'Le troisième signifiant', *Terre d'images* 3 (May–June 1964).

possess. Thus what images gain in *impactfulness*, they often lose in *clarity*.

PILARD. Mathematics gives us an example of a thinking that has progressed largely thanks to the use of a system of signs and original visualization procedures. But it isn't, apparently, solely because they are *spoken* by articulated language that these systems and procedures have proved fertile.

BARTHES. The use of visualization techniques certainly won't be brought to an end by the particular virtues of articulated language. Generally, in most efforts at visualization that are attempted, the image is used as a vehicle for abstraction. The concrete image is supposed to get through to an audience better than articulated language, though this latter actually seems ideally suited to *abstraction*. Abstraction conveyed by language is most often an absolute conceptual necessity—and not just at the level of high discursive intelligence. When, using articulated language, we say 'apple', this has the very great advantage of not referring to any particular apple. It's for this reason that communication is possible. Articulated language enables us to manipulate abstractions: in saying 'apple', it is *the apple in itself*, if I may venture such a proposition, that we're handling, linguistically speaking. But as soon as we try to translate that abstraction into an image, however schematic, it is always *a particular apple* we draw—and refer to.

In some cases, there may be great advantages in this, but also great disadvantages, for there are a considerable number of mental operations that require the power of abstraction of articulated language. This is why I think it's premature to say that we should—or that we easily or naturally can—*translate* notions or propositions from articulated language into images. In fact, we know very well that no translation, which always involves a deeply difficult choice, can ever be exact . . .

I think we have to be cautious, then, when we speak of a *language* in relation to images. There can be no doubt that, as ever, empirical research will precede speculative thinking in this area by some distance. Research in the area of visualization, in the audiovisual and its teaching, is necessary and often positive. But this practical research is very far advanced by comparison with what we know about language. Even in linguistics, which is a very advanced science, there are still many things we don't know and, at times, we even have to revise interpretations we'd previously arrived at. For example, the recent linguistic research carried out by the American Chomsky is tending to produce an anti-behaviourist linguistics.[7] Chomsky

7 Noam Chomsky, 'A Review of B. F. Skinner's Verbal Behavior' in J. A. Fodor and J. J. Katz (eds), *The Structure of Language: Readings in the Philosophy of Language* (Englewood Cliffs, NJ: Prentice Hall, 1964), pp. 547–78.

now thinks that there is in human beings, as a particular animal species, a kind of *language faculty*, an anthropological disposition to language related to a logical structure of the human brain. As a result, the problem of articulated language wouldn't simply be a problem of learning. Learning alone doesn't explain why a young child begins to speak.

PILARD. So that's an anti-Pavlovian perspective . . .

BARTHES. Yes. And the optimism that appeared with the first attempts at visualization was based on a conception that remained very close to behaviourism. The consequences of Chomsky's theory don't lead to a denial of the very real powers of the various iconic techniques, but they lead us to think that we can't treat the two learning processes as though they were equivalent and expect that to work out. This is why the project planned for the developing nations, in which the aim is, more or less, to *skip* the learning of articulated language and writing in favour of images—or at least by way of them—a project in which it's claimed that we can move directly from illiteracy to a state of knowledge acquired through images, seems to me to be unfounded as yet. I believe that if humanity sets itself a basic cultural task, this has to be to teach people, at a deep level, *to speak* . . .

PILARD. The optimism you were just speaking about has found expression in faith in a sort of possible visual *koine*, a kind of 'iconic esperanto' that would

enable human beings to understand one another better . . .

BARTHES. Yes, this *koine*, this 'vulgate' of visual symbols and signs common to all human beings, may be very useful, but all that's achievable in this area are codes that are extremely *restricted* because they are *analogical*. And, above all, we shouldn't forget that communication is merely a partial aspect of language. *Language is also a faculty of conceptualization, of organization of the world* and hence much more than mere communication. Animals, for example, communicate very well among themselves or with human beings. What distinguishes human beings from animals isn't communication but symbolization—that is to say, the invention of non-analogical sign systems. Recent philosophical thinking on this subject, such as that of Ruyer,[8] leads to the idea that, paradoxically, language came to human beings only through a halting of communication. We're talking here about the difference there is between *talking to someone* (which is of the order of communication) and *talking about something* (which is of the order of

8 Raymond Ruyer, 'L'homme, le symbole'. Barthes's rather gnomic reference here is probably to the chapter 'L'homme et la fonction symbolique' in Raymond Ruyer, *L'Animal, l'homme, la fonction symbolique* (Paris: Gallimard, 1964), pp. 87–103. [Trans.].

symbolization). In the current state of things, images are mainly part of *communication*.

PILARD. It's been argued that this 'culturation' by audio-visual methods could be profoundly disruptive for those receiving it, generating a real substandard culture.[9] What do you think of that?

BARTHES. I think the problem comes down wholly to determining what, within knowledge, can be aided by visualization or any other pedagogical technique. There's a whole area of mental activity that can never be reached by visualization and the audiovisual technicians know this very well . . . The idea that we're now in a *civilization of the image* has been repeated time and again. But we forget there are virtually never any images without words, either as captions, commentary, subtitles or dialogue, etc. I'm more inclined to think that humanity has so far lived through *the prehistory of articulated language* and we're now at last coming into a civilization in which language will be properly understood and exploited. The efforts made in the field of images and visualization remain to be made in the field of articulated language. We can't say, just because we speak our language or we've been taught certain discursive techniques,

9 See Gilbert Cohen-Séat and Pierre Fougey-rollas, *L'Action sur l'homme: cinéma et télévision* (Paris: Denoël, 1961).

ROLAND BARTHES

that we're masters of language. The whole way human beings wrestle with their language hasn't yet been scientifically explored. *I really believe that we're now entering upon the true history of language . . .*

Japan:
The Art of Living,
the Art of Signs

(An Interview by Guy Gauthier
and Philippe Pilard)

Oeuvres
complètes,
Volume 3,
pp. 84–90

This second interview was also carried out by Philippe Pilard, accompanied on this occasion by Guy Gauthier, a film critic specializing in the documentary field who taught cinema at Paris-VII University between 1971 and 1984. Gauthier also wrote extensively for the magazine *Image et son* in which this interview appeared in December 1968. *Image et son* underwent a name change in March 1969, becoming *La revue du cinéma*.

The interview largely concerns Japanese cinema in its relations to that nation's visual culture as a whole. Barthes had made a third trip to Japan the previous winter, staying from 18 December 1967 to 10 January 1968, and had written his first piece on the country, 'Leçon d'écriture', in the summer of 1968. That text, originally published in *Tel Quel* 34, is translated as 'Lesson in Writing', in Stephen Heath (ed.), *Image, Music, Text* (London: Fontana, 1977), pp. 170–8.

GUY GAUTHIER AND PHILIPPE PILARD. What has your experience of Japan been like?

ROLAND BARTHES. It's been a very individual experience, limited to problems of the art of living.

GAUTHIER AND PILARD. Can we take the view that a cultural system—including cinema—can reach and be understood by a totally different audience? If there is communication, how can it happen?

BARTHES. As I see it, there are three problems here: Western lack of knowledge of Asia; the relationship between Japan as seen from here and Japan as it actually is; and the problem of cinema in Japan, which we can, in fact, link to the problem of the theatre.

In Tokyo—since we always have to situate ourselves within the context of a city that's exemplary on a world scale (an immense geographical space that the term city hardly does justice to)—or in other conurbations such as the one formed

by Kyoto, Osaka and Kobe, you can see three functional types of cinema. First, there's the everyday type with mainly commercial films, constructed in accordance with international stereotypes. These are often very well made and are imitated from Western models. The traditional variant is set in feudal Japan with period costumes and sets. As physical works of art, these latter films seemed to me extremely tasteful. The Japanese visual world is an admirably refined one—there's a very attractive sort of aesthetic metaphysics. Yet these are films that play in cinemas in working-class areas. The films aren't dubbed, so obviously I was only able to follow the images. Nevertheless, I had the impression that the films were based on very stereotyped stories provided by Japanese literature. The second category consists of the foreign films that are shown in specialist picture-houses, though these remain neighbourhood cinemas nonetheless. It isn't only American films that are shown but also French and Russian ones. In fact, all nationalities are represented. The Japanese public is somehow hungry for all these films, being in no way selective about them. So in a dubious-looking basement in a Tokyo neighbourhood resembling Pigalle, you can see really low-grade French films. I saw *Château en Suède* [Roger Vadim, 1963] like that. It felt like a throwback to see that third-rate little thing being accepted; to see the naive, non-aggressive, non-judgemental attitude towards the

foreign film. This chimes entirely with one of the great constants of the Japanese ethnic group which always astonishes Westerners—the fact that an entirely insular country, completely locked in to its national traditions, has also been the most assimilative country in the world. The strength of Japan as a nation comes from its power of assimilation: first of Chinese culture, and now of technology. It's this power that we meet again where cinema is concerned. They assimilate, they silently absorb all kinds of foreign films . . . The third category, famed in the petty mythology that surrounds Japan, is erotic cinema, which enjoys very great freedom of expression. There are little specialist movie theatres that operate all night and aren't censored. What they show there is, clearly, a coded eroticism, unthinkable in our country and predominantly sadistic but highly stereotyped. That form of cinema could serve as a way in to Japanese sadism. In daily life, the Japanese show admirable self-control, a total absence of aggression. It would seem the cinema absorbs the 'sadistic potential' which is liberated at the level of fantasy images. My argument may perhaps be flawed, as there have been episodes in Japanese history that seem to show evidence of 'Japanese cruelty'. But we'd have to look closely to ensure that isn't part of a tendentious mythologizing on the part of Westerners.

GAUTHIER AND PILARD. What's striking when you see a lot of Japanese films is the difference in the way they view film direction. Ozu is the prime example here: the camera stays at ground level and takes very wide shots, with very long sequences and none of the Western penchant for cutting. Do you see that as a specifically Japanese effect?

BARTHES. I'd be tempted to relate this to residential architecture, to the domestic space in Japan. Japan has developed a civilization of habitability, of houses in gardens. The Japanese house is low-rise, has little or no furniture and seems designed to see oneself from quite low down and in one's full breadth. It implies a kind of extension where the body is concerned. It excludes verticality. Space is much worked on but on the horizontal level, with very fine views of corridors and covered wooden galleries. It's the country of connection. Gestures are connected. There's an ancestral practice of the human body there that's profoundly steeped in Buddhism. The sense of the body is different from what it is in the West. The extraordinary control of the Japanese—and of Asians in general—over their bodies produces this very particular 'connectedness' not only between gestures but also between gestures and objects. It's very difficult to explain, but incontrovertible. It would be interesting to look into the relation between the cinematic visuality arrived at by film directors and inhabited space—that is to say, architecture, urbanism, etc.

GAUTHIER AND PILARD. In your view, is there in Japanese cinema an extension of the art of the sign that characterizes the Japanese theatre?

BARTHES. I don't think so. It seems to me that in the expression 'Japanese cinema', the cinema element is much more important than the Japanese. For example, the typology of Japanese actors doesn't seem representative of what one sees in the street in Japan. There are some obscure phenomena there that would require study. Very rarely does a Japanese actor induce in me the kind of physical sympathy that I've felt a thousand times on the streets of Japan. There's a hiatus there I'd have liked to have given some thought to . . . Perhaps the Japanese—particularly in their cinema—have a de-Japanizing temptation . . . In the theatre, by contrast, they're completely up front about their 'Japaneseness'. To finish this point, we ought to ask ourselves whether, after all, French actors are representative of the French as an ethnic group. Or, rather, we should ask foreigners that . . . Do foreigners have the impression of a continuity between people they see in the street in France and actors as prominent in our films as Belmondo or Delon?

The theatre's another matter. What's called Japanese theatre is a traditional form of drama that's still highly regarded but already somewhat anachronistic. Noh has become a special kind of

theatre with a small audience—it is a theatre for the scholarly. The Japanese masses don't go to Noh theatre. Noh assumes a high cultural level; it stands completely apart from the mass culture in which Japan is now steeped. Kabuki, in theory a more popular art form, actually plays to constantly packed houses. But there's only one theatre for the whole of Tokyo and the audience isn't particularly young. It is my impression that what we call 'the youth' don't go to this Kabuki theatre and that their tastes are more 'American'. There's a big audience for naturalistic theatre in the Western style. This plays in other parts of town, the equivalent of the London West End or New York's Broadway, where huge audiences go to see Japanese actors perform adaptations of works like Stendhal's *Red and Black*.

The Kabuki theatre provides a wonderful lesson in semantics. It's a theatre of signs, not at all grounded in expressiveness. In Kabuki, the body offers a sort of wholly coded repertoire. I can simply refer the reader here to the pages, now well known, that Brecht devoted to Chinese theatre, pages which are relatively prophetic. The Kabuki repertoire is varied and heteroclite: pantomimes in the ancient style, legendary tales but also modern stories translated into the idiom of Kabuki. As an example, I may cite the story of Tosca, Japanized and acted using the Kabuki technique,

with the women's roles taken by men. And this is, in fact, extremely interesting. The prima donna's role was taken by an extremely famous male actor of fifty or so. He played the role of the young woman to perfection precisely because the conception of signs is different. He didn't copy the young woman in the naturalistic, Western sense of the term; that would have been insufferable. What he reproduced were the wonderfully coded signs of femininity. There was nothing embarrassing about it and it prompted an admiring reaction from the audience, simply because the code was well 'performed', as the students of linguistics say. In Kabuki, the actors' faces aren't in any way 'made up'. They're genuinely painted—with a plain white mask—and the Japanese character of the eyes is greatly accentuated. We have here the whole philosophy of the mask—these are faces impassive in their very morphology but at the same time extraordinarily fragile. Many things can be read on them, but read from a surface that remains perfectly still.

There's also the puppet theatre, Bunraku, which has more or less the same repertoire as Kabuki. The exhilarating thing is that the puppeteers are completely visible. There's no kind of deception about the way the puppets are manipulated. Each one has three puppeteers, two of whom have their faces covered with black

hoods while the main one has his face uncovered, a face that is itself impassive and not made up. The relation between this little three-foot-tall man or woman and the puppeteers is very impressive and tells us a great deal about the morality of the theatre, which isn't an art of illusion but an art of overt, declared signs. The whole meaning is in the visuality. The whole emotion is concentrated in the role of the chanters who perspire, weep and moan. There's a very fine distribution of functions here—all the expressiveness is concentrated in the voices and visuality has just a semantic role, involving extraordinarily subtle aesthetic exploration.

I'm not too clear what cinema has managed to make out of all that. It seems to me beyond question that there'll be elements of Noh, Kabuki or Bunraku that have found their way into certain films . . .

GAUTHIER AND PILARD. The Japanese have a very pronounced taste for science fiction. Do you think this is an expression of the modernity—the Americanization—of Japan or is this taste actually rooted in tradition?

BARTHES. I think we shouldn't automatically equate high technicization with Americanization. Japan can provide proof of this. The Americanized elements of Japanese life are perhaps attractive to young people when it comes to songs, music and dance . . . But the permeation of Japanese life by

technology isn't American at all in its outcomes. I'm very comfortable with life in Japan. This is perhaps an individual experience, but it seems obvious to me that Japan is currently producing a synthesis, with some very recent aspects to it, between an art of living that originates in feudal times and technical modes of life: two 'alienations' which, by combining, cease perhaps to be harmful. When I say 'art of living', I'm not in any way thinking of the picturesque or the quaint. This isn't backward-looking. By 'art of living', I mean a profoundly elaborate practice of everyday actions, clothing, hospitality, etc.

As for science fiction, I'd connect that to the fact that the Japanese have some marvellous toys which are often science-fiction-based. There's the taste for miniaturization, for automata, which can be related to Kabuki or Bunraku. Japan is a consumer society which certainly has its alienations, but it has succeeded in raising the sight of things—and not just their possession or use—to the rank of a consumer value.

There is, in Japan, a somewhat phantasmatic art of machinery and technology.

GAUTHIER AND PILARD. Can we take the view there's a kind of anthropological spectatorial imaginary in Japan, expressed in semantic systems that differ between one culture and another? And can we speak of a deeply original Japanese system?

BARTHES. Since Claudel, who wrote some interesting passages on the kind of sign he'd encountered in Japan—'the sign is a being', 'the religion of the sign', etc.—into which he artfully injected some of Mallarmé's theories, we've been aware of the distinctiveness of the Japanese semantic system.[1] The distinctive aspect is that this systematics of the sign is empty; and indeed, that's why I find it very affecting. The signs are empty because Japan is a country without religion in the Western sense of the term—that is to say, a country without monotheism. One feels the fact of being in such a country from this conception and practice of the sign. With the religion empty at the level of God, this means that there is no signified; it means that there are signs, but signs without that ultimate signified that is God. Our Western semantics is bound up with the fact that we're a monotheistic civilization and we place a signified behind signs. From layer to layer, our entire system of signs culminates in filling an ultimate sign with a transcendence, a plenitude, a centre, a meaning. This is where the distinctiveness of Japanese semantics lies: an extremely supple, very strong, very subtle, highly elaborate systematics which is, at the same time, very clear but whose signs are ultimately empty. This is the reign of the signifier and, to that

1 These phrases come from Paul Claudel's collection of prose poems *Connaissance de l'Est* (Paris: Mercure de France, 1900).

ROLAND BARTHES

extent, Japan can stand for the coming of a civilization of the signifier. All this is very closely connected with what is currently being debated in France by way of structuralism. It isn't a model, because there are some very marked grey areas. These relate mainly to political and economic problems, since we're talking about a capitalist country and even one that's exemplarily so. Perhaps what I'm saying about Japan could be said even better of China which is the land of the ideogram.

GAUTHIER AND PILARD. On that score, what influence does ideographic writing have on the arts, particularly film?

BARTHES. We now know, from work done by Derrida and Lacan's school, how significant the literality of writing is: the fact that we have alphabetic rather than ideographic writing is extremely important. The entire life of the Japanese people is steeped in ideographic writing. It has an incalculable impact on the position of the human being in space, on thought and in all areas. The fact that writing is regarded as equal in status to painting, and that painting is, so to speak, derived from writing, rather than the other way about, is also very important. In modern Japanese life, despite or through technicization, calligraphy remains present. The big stores all have a sizeable department given over to calligraphy. The gesture of writing, an absolutely corporeal gesture, is present

in all areas of life. We may say that many more things than language are written. Coming to a better definition of writing as gesture, we might get back to problems of cinema. The felt-tip pen that comes to us from Japan develops out of a whole practice that couldn't have given rise to the ballpoint. The difference between civilizations involves objects as basic as those . . .

GAUTHIER AND PILARD. Don't you think that cinema, which is a heavily analogical system, offers resistance to coded signifying systems?

BARTHES. I was going to say: Can a writing [*une écriture*] be made with the mobile? I don't mean with movement, but with the mobile? The answer is no doubt yes, since that happens in theatre. But theatre writing is resistant to movement. Oriental theatre plays on moments of stillness. By contrast, cinema, as a result of the analogical constraint you mention, no longer even has that freedom. It records things at the pace of reality, whereas movement in Kabuki is slowed down, broken down . . . As for seeing the cinema take over from these sign systems, I have great reservations about that. All sign practices have the threat of aestheticization hanging over them . . . In any event, cinema is still very new. Nothing is settled. And can we, in fact, say that Western cinema has assimilated Western culture?

What Is Good...

Barthes first met André Téchiné at Cannes in 1972, where Téchiné's first film *Pauline s'en va* was being shown at the fringe festival. They became close friends and the young filmmaker began to attend Barthes's seminars. Téchiné's second film, the consciously Brechtian *Souvenirs d'en France*, was a candidate in the official competition at Cannes in 1975. This review by Barthes was written for *Le Monde* in September of that year. In 1979, Barthes would play the role of William Makepeace Thackeray in Téchiné's film *Les soeurs Brontë* (see 'There Is No Man', pp. 135–40).

Oeuvres complètes, Volume 4, pp. 797–9

The so-called political film has often seemed to me to have something Wagnerian about it, to produce the same feelings Wagner inspired in Nietzsche. You recognize it as powerful but feel it is artificial; ponderous as a duty but effective as a piece of moral magic. In short, it is almost always, like Nietzsche's Wagner, a misunderstanding. With André Téchiné, *lightness* begins ('What is good is light; whatever is divine moves on tender feet'[1]), a development that means as much to the theory of film-making as it does to the practice of film-watching: committed art is at last changing its language regime and something of a very everyday kind is once again afoot—the pleasure of going to the cinema. To a cinema 'that doesn't perspire', either politically or commercially.

[1] Friedrich Nietzsche: 'Das Gute ist leicht, alles Göttliche läuft auf zarten Füssen', *Der Fall Wagner*.

Where does this lightness come from? It has to do, first and foremost, with the fact that it is objects that are treated politically. When Brecht wants to deal with the enormous question of the collusion between commerce and war, what he puts on the stage is a belt buckle. When Téchiné wants to express that cumbrous historical complex that is the interplay of morality and self-interest within a bourgeois family, what he puts on the screen are carefully ironed tea-towels, coins, pairs of spectacles, hands. If American capitalism bails out the old family industry, it does so in the guise of a red typewriter at the hand of a bored, whisky-drinking, cigarette-smoking secretary. And, similarly, the social classes rubbing together becomes a whirl of umbrellas as the audience turns out from a provincial cinema (Oh, these south-western downpours!). Doesn't art begin when objects are made intelligent? André Téchiné's objects have a mildly bombastic air which makes them entirely clear and seemingly happy (if not, indeed, a little intoxicated) with their state.

Téchiné's is an art more elliptical than allusive; it is highly readable and yet free of any narrative prejudice (hence a bit mad). He has been praised for bringing a new novelistic art into cinema (Siclier has done this in these very pages—and quite rightly). And yes, there is something of the novel in his films, not in terms of narrative genre or psychological pathos but through a necessity of language. Téchiné knows that genres aren't good or bad in themselves but that each is connected

to some grand structure of human history: the bourgeois family can only speak itself through the novel, because it is the same thing. Téchiné's story is, however, highly perverse. On the one hand, the episodes, separated one from another, carry an absolute meaning—they are the pregnant moments Diderot favoured or features of the social *gestus* of the kind Brecht wanted to see (in passing, we should say that André Téchiné's film is an entirely Brechtian work, though fortunately that is not immediately apparent). On the other hand, these episodes are so clear, so seductive, that they create what we might term gaps in the narration. Now, paradoxically, it is these gaps that carry the story forward and lend it meaning, without bogging it down in a progressive (and fallaciously progressive) temporality—time no longer ensnares. The achievement here is to have dared to apply to the cinema what we know of the absences of the narrating subject (this doesn't necessarily entail a semblance of psychosis). Viewers can test out how new this style of narrative is by observing that, against all expectations, they are not remotely put out to see actors' faces not ageing at all throughout a long story. So adding wrinkles and powdering hair was an unnecessary sham—and has been so for many years! What need is there for Berthe, Régina or Hector to degenerate physically simply because the chronology of the film takes us from the Popular Front to the Resistance? The important thing is their desire. They desire—both sensually and socially—and it is for that reason that the story (theirs

and ours) works. Desire is timeless, like the philosopher, according to Nietzsche.

To transmute rather than to age means things are prevented from 'coming together', coagulating and being alienated in the illusory trap of destiny, the neurosis of time—what 'develops' (as the expression goes) becomes static. The most serious word in cinema is 'Cut!' The word sets a *tone*. André Téchiné's irony is very paradoxical. It is an irony that has nobility as its secret mainspring. It prevents spitefulness from settling in and detaches it from lucidity like a useless skin, thwarting, to some degree—and, so to speak, amiably— that hint of paranoia that ordinarily governs the production of intelligent works. In short, it serves to put into a spectacle—though one that has few illusions— a sort of big-heartedness. There is no caricature here, merely rapid distances, linguistic zooming. Nothing is imitated; things are merely *displaced* (they are not in their place). In the course of a fierce bout of—moral and pecuniary—haggling, Berthe, the linen maid, unexpectedly comes out with a long, refined, sophisticated line. This is a short, sharp episode, like a piece of music-hall comedy, the airy signature of a madwoman's raving. But that raving *triggers* the bourgeois discourse of old Augustine—the false talk falls right out here, like dregs sinking to the bottom of a bottle. Is it funny? Yes, it is. But it is particularly so because this is an art which disjoins without destroying (why do we need to destroy languages? To disjoin them is

sufficient) and that lightens things. And lightness—
that particular lightness made up of watchfulness and
elation—is ultimately what? It is *a certain emotion*—at
last!

Like That

Barthes published this review of the American photographer Richard Avedon's collection *Portraits* (Paris: Éditions du Chêne, 1976) in the mass-market magazine *Photo*, founded in 1967. It appears to have been his only contribution to that publication. The book in question was the French translation of a 1976 work of the same name published by Farrar, Straus and Giroux, comprising photographs by Avedon and an essay by the Marxian cultural critic Harold Rosenberg.

Oeuvres complètes, Volume 5, pp. 299–302

Avedon, one of the most eminent of American photographers, was for many years a leading figure at American *Vogue* magazine. Exhibitions of his work have been held at the Metropolitan Museum of Art and the Whitney Museum of Modern Art in New York, the Centre Pompidou in Paris and many other major museums across the globe; many galleries hold his photographs in their permanent collections.

Avedon's multi-panel photographs of Warhol and his entourage of aspiring actors and directors from 'The Factory', depicted in varying degrees of undress (including full-frontal nudity), are among the best-known photographic works of the late 1960s. Two of Avedon's portraits—of William Casby and Asa Philip Randolph—figure in Barthes's *La*

Chambre claire (Paris: Gallimard/Seuil, 1980; English: *Camera Lucida*. New York: Hill and Wang, 1981).

Look at a photograph by Avedon and you will see in action the paradox of all great art—of all thoroughbred art: the finite extreme image opens on to the infinite extreme of contemplation and astonishment. We say, rather mindlessly, of so many photographs that they are 'lifelike', 'vivid', etc.—all these being mythic values played on by advertisements for photographic equipment! But Avedon's art lies in making *motionless* photographs—photographs that are, as a result, objects of *endless* fascination. That which fascinates is both dead and alive; that is why it is fascinating. The bodies Avedon photographs are, in a sense, corpses, but these corpses have lively eyes that look at you and think—this realist art is also a thing of fantasy.

This produces a committed art, immediately opening up a social critique, though it does not fall into the stereotype of commitment: in some of the photos of his that I've seen, Avedon shows the opaqueness,

hardness and involuntary sadness of the American establishment—all those things that make the established artist a closed body, too interested in power and too little in pleasure [*jouissance*]. But in another section of his work and sometimes in the same photos (why not? history is complicated), without departing from his style he gives us something quite different to look at: pensiveness, a gentle severity, intelligence stripped of the poses of intelligence and gathered wholly in the eyes which never lie. This is why, standing before an Avedon photograph, you are always communicating with the models: not only do they speak to you, or, even better—since it is the more heart-wrenching—they *want* to speak to you, but you answer them, you want to answer them, as is shown in your very inability to detach yourself from this image which holds you without repeating itself (so is it, then, an *amorous* relation we have to these photos?).

I spent a whole evening like this, looking at Avedon's photographs; the evening before, I'd been to the cinema, where I'd been rather bored. I found myself comparing the two arts (albeit somewhat unjustly). Avedon's draws us towards a theory of Photography that has unjustly been sacrificed today to a flourishing film theory or even a theory of the strip cartoon. As production, Photography has been taken prisoner by two unacceptable alibis: at times it is raised to great heights as 'art photography', a category that precisely undermines photography as art, while at others it is

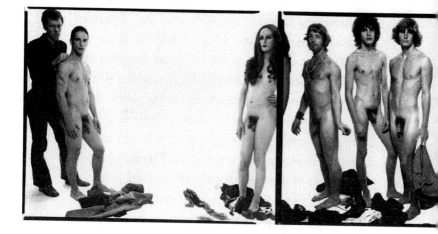

Andy Warhol and the Members of the Factory, New York, 30 October 1969.
(From left to right) Paul Morrissey, director, Joe Dallessandro, actor, Candy Darling, actor, Eric Emerson, actor, Jay Johnson, actor, Tom Hempertz, actor, Gerard Malanga, poet, Viva, actress, Paul Morrissey, Taylor Mead, actor, Brigid Polk, actress, Joe Dallessandro, Andy Warhol, artist. © The Richard Avedon Foundation.

lent virility as reportage, a form of photography that derives its prestige from the subject it captures. But the Photograph is neither a painting nor ... a photograph; it is a Text, that is to say, it is a complex—extremely complex—meditation on meaning.

Here, for example, are all the things I *read* in a photograph by Avedon, the seven gifts it gives me: first of all, the true, the truth, the sense of truth, the exclamation of truth ('how true it is!'); then, character (pensiveness, sadness, severity, satisfaction, cheerfulness, etc.); then, the type (the politician, the writer, the manager); then, Eros, a commitment, either seductive or repulsive, to affect; then, death, the fact that we shall one day be corpses; then, the past, what *was* captured from the past and cannot come again, cannot again be touched; lastly, the seventh meaning is precisely the one that resists all the others, the inexpressible supplement,

the clear understanding that in the image there is always *something else*—the inexhaustible, uncompromising element of Photography (desire?).

Avedon's photographs always take me right along this path and make me endlessly begin it again. With them, the journey is never finished. They are rich and bare at one and the same time, are constantly giving and constantly holding back. In short, they are the very figures of a dialectic: there is the greatest intensity of meaning in them and ultimately the very lack of meaning—something of a bliss [*jouissance*] unfulfilled. At the very beginning, meanings proliferate and excitement is at its height; then, under the influence of an inflexible though supremely discreet hand—the hand of Avedon—meaning thins out: for the body represented, no *certain* adjective remains. It seems to me that if I were photographed by Avedon, I would (at last!) no longer want to judge my own body (like everyone else, I have uneasy relations with my body image), would have no wish to find myself too much *this* and not enough *that*—my body would simply be stubbornly intent on being, on persisting. Avedon's photography *has no trickery in it* (contrary to the photographic image): no one is ugly, no one is handsome (except, in an exception that marks the rest of the project, the two naked boys from Andy Warhol's 'Factory'). In short, I would be *like that*, and in this '*like that*' of my body, I would perhaps experience something of the serenity of the great Eastern sages.

On Some Photographs
by Daniel Boudinet

The following text appeared in issue 4 of the fine art photography magazine *Créatis* as the commentary to the 12 photographs by Daniel Boudinet that it contained. The issue was devoted entirely to the work of Boudinet; others in this same period were given over to the photography of David Harali (no. 3), Man Ray (no. 5), Robert Mapplethorpe (no. 7) and Raoul Haussman (no. 9).

It is generally accepted that the heightened interest in photography that resulted in *La Chambre claire* (*Camera Lucida*) was prompted by the death of Barthes's mother and his prolonged examination of old family photographs as part of the grieving process. According to Tiphaine Samoyault's recent biography, Boudinet was one of the people Barthes consulted before he began writing that book, and one of Boudinet's recent photographs, *Polaroïd* (1979), appears as the frontispiece to the French edition.

The issue of *Créatis* on Mapplethorpe is also cited in the bibliography to *La Chambre claire*.

Oeuvres complètes, Volume 5, pp. 316–29

Photographs are like words—forms that immediately mean something. There is nothing else for it, I am forced to go to the meaning—or at least to *a* meaning. The status of these systems is paradoxical: no sooner is the form there than it disappears and gives way to a supposed reality—that of the thing said or the thing represented. This unavoidable fact unites the writer and the photographer, though the painter remains freer. Hence, for each of them, their aesthetic is always encumbered: literature, the highest form of verbal substance, must multiply the signs that distinguish it from everyday language which is, they say, the language of simple communication; and photography, condemned by a whole series of historical and social usages (that is to say, alienations) to the 'objective' representation of visual facts, finds itself constantly stuck between a functional status—reportage (faithfully recording at the right moment)—and an emphatic status—what is called 'art' photography. For these two

signifying orders (literature and photography), the modern task is therefore more or less the same (I say 'more or less', given how blatant the historical differences are): the point is to produce—by a difficult work of exploration—a signifier that is both unrelated to 'art' (as a coded form of culture) and to the illusory 'naturalness' of the referent.

This is a precarious mountain path between two abysses—of naturalism and aestheticism. I needed to sketch it out before saying how, as I see it, D. B. manages to walk that path—with exactitude, strength and subtlety.

*

Several members of my circle of friends, when chancing to pass by this thicket of trees that stands on my desk have said, 'How beautiful!' The story told by these twelve images begins with a burst of delight (I am moved to cry out); but what grabs me isn't a spectacle, a scene or a 'view' but a weave of foliage, a delicate fabric—the substance is both bushy and light, chaotic and centred: this vertical tangle of greenery, both airless and sky-less as it is, inexplicably helps me to breathe; it elevates my 'soul' (as we would have said a century ago, though the soul is always the body) and yet I also want to plunge into the darkness of the earth. What we have here, in short, is a mottled mass of intensities.

(FACING PAGE) *Lush Foliage, used in the series 'Fragments of a Labyrinth'.*
(ABOVE) *Path Leading to a Village.*

How many cultures are caught up in this view! First, in the literal sense, there is the culture—the cultivation— of the earth; but there are also all the cultures (in the metaphorical sense) that inform my gaze: geography (a particular vegetation, particular roofs, a particular church tower), history (the whole village gives off something like the scent of ancestral time), rurality (I love this path that connects the dwellings to the working of the earth). The place is tight, coherent and intelligible, but, as ever, D. B. opens and frees it up by his way with foliage.

(FACING PAGE) *Work in the Fields and Rows of Fruit Trees.*
(ABOVE) *Rural Landscape and Cattle.*

The two trees at the sides are like the inverted commas around a great visual quotation in which all *peaceful* pictures are gathered together by superimposition. The author expresses peacefulness indirectly, so that we may rest, for if he said it directly, no effect (or an opposite effect) would ensue. Ordinarily a photograph *asserts*, but here it *produces* peace.

The meadows and the roofs are made of the same stuff, the same woolly fabric. The 'rural' is that space where human product and natural product are indistinct, where they form a single substance. Now, photography is that optical, graphic instrument that creates a more rigorous identity than is produced in painting. It is a subtle tint-drawing in which the human being is no longer present in what he constructs but only, like two very localized signatures, in what he catches (with an age-old gesture like the fisherman) and what he avoids (the road curving away). The curtain of trees stripped bare by winter is a grid through which we can read a very primitive human story—how the human being gradually extricates himself from his nature as a *procryptic* insect.

(FACING PAGE) *Tree in Flower and White Hen behind the House.*
(ABOVE) *Work in the Fields, Rows of Tomatoes.*

This is a Georgic in the French style—nature as veg-
etal mass retreats beneath the hoe of a timeless crea-
ture (the action, the bonnet . . .) *clearing ground.* Yet
there is no combat (with the earth) here but something
austere and neutral. Seen from a distance (in time and
space), as the mere signature of a contrived landscape,
work assumes its mythic value which is to be a force
of liberation and pacification.

A photograph only has worth if one desires (even in rejecting it) what it represents. This is even a good criterion for deciding whether a photograph *exists* (let's not talk of art photography any more) or if it is consigned to the massed ranks of the insignificant snapshot. Everything D. B. photographs I desire—his work, at every moment, establishes the space in which I wish to live (at least I believe so). No doubt the meadows and the trees in blossom, the old sloping roofs and the brightly white hen (whose whiteness miraculously dispels the stench of farmyards) make up only a very small part of my desire; it is merely a naive city-dweller's desire, but a desire, we may say, doesn't have to be total to be entire.

(FACING PAGE) *Orchard and Fruit-Picking.*
(ABOVE) *Rural Landscape and Cow.*

Another Georgic. Here the whole force of labour is conveyed by the signs of its suspension. Trees, animals, ploughing instruments have all returned to a kind of stubborn determination to rest. By its gathering and spacing of these temporarily inactive (but not idle) agencies, the image expresses the time, the tense; we have just been working, producing (milk, hay) and we are going to begin again. Ordinarily, the photograph is said to grasp what is current; here, more philosophically, it expresses that difficult thing—the present.

This orchard is perhaps a modest, hard-working place (though is it even an orchard?). It matters little. Through a whole art of images, it makes itself into a *formula*. And the formula of the orchard enables me to accede vaguely but with delight to a whole culture: myths, poems, folktales, songs, paintings and tapestries ('culture' isn't necessarily repressive; insofar as it remains a confused memory, without demanding exactness, it allows me to blossom, magnifies me).

I would like to speak about the white horse, a very ancient symbol of beauty. But beauty is something shown, not something spoken. The horse merely partakes in the joy of the whole dark, blossom-filled space, of which it is merely the distant signature (all D. B.'s landscapes are *signed*—but only signed—with the hieroglyph of the animate).

(FACING PAGE) *Orchard and White Horse in Background.*
(ABOVE) *Alsace, 1973.*

D. B.'s photographs are very musical. They have a soothing effect and a kind of subtle, never violent *catharsis* is at work—the body breathes better, it *drinks* what Baudelaire called '*the vegetal ambrosia*'.

(FACING PAGE) *Goose and Cabbage.*
(ABOVE) *Alsace, 1973.*

Which object has been most painted throughout human history? Probably the tree. The forward march of painting coincides with the successive distortions artists have wrought on the tree. D. B., as we know from the beginning of this story, is a painter of trees. A very deep desire binds him to them. For him, the tree isn't a form (there is great audacity in this) but a substance—a light, tight, luminous, moiré substance that might be said to be stretched out upright (if such a phrase can be permitted) against the backcloth of meadows and roofs.

All photographs by Daniel Boudinet ('Alsace' series) © RMN-Grand Palais. Photo Ministère de la Culture-Médiathèque du Patrimoine, Dist. RMN-Grand Palais.

D. B.'s Georgics could only end on the image of the earth (rich, fertile soil). The earth seen close up: humus, twigs, puddles, debris: germination and putrefaction. A duck with its strong-tasting meat, a cabbage gnawed away by the sucking of slugs—like an inevitable overturning of the beauteous, tree-studded Nature we are leaving behind. And yet close your eyes. The trees remain dazzlingly in our heads; they are imprinted on the insides of our eyelids. You can't shake them off. Thanks to a sort of confused visual remanence, you see not some particular image but a kind of sumptuous, austere vegetal expanse, a sort of silent invitation to . . . 'philosophize'.

Colouring, Degree Zero

*Oeuvres
complètes,*
**Volume 5,
p. 453**

Barthes produced a great many little extemporized abstract drawings for which he himself struggles here to find an appropriate description. There may be as many as 700 such drawings in existence. Some 380 are held at the Bibliothèque nationale in Paris.

The following was a short piece which he contributed to a survey that asked a number of writers whether, and to what extent, they engaged in drawing or painting. It was published by *Les Nouvelles littéraires* on 30 March 1978, then again after Barthes's death, on 3 May 1980.

From time to time, I like to do ... but here the difficulty begins—to do what? Drawing, painting, graphic art ... ? What I do barely has a name. It's more of the order of colouring, of graffiti. It's not, assuredly, a second-rate thing but a by-product, a spin-off, even though it's always subject, more or less, to cultural values that I derive, without thinking, from all the paintings or forms of handwriting I've seen. I like the process of production itself, but I also like to be able to view the product with pleasure, the proof being that, if I think it hasn't 'worked', I throw it away. In this incidental operation, there is then, all the same, a sort of aesthetic aim. With no illusions, but with some joy, I play the artist.

There are no doubt many reasons for this amateur practice. Perhaps it's the dream of being a complete artist, a painter and writer, as certain men of the Renaissance were. Or the desire to extend the use of my body, to 'turn my hand to something else' (even if

it's still the right hand). Or the need to express a little of the drive that's in this body (they say that colour equates in some way with the drive [*pulsion*]). Or, conversely, the pleasure of a sort of cosy sense of craft-work (laying out one's pastels, inks, brushes and sheets of paper on a workbench). Or even the relief (the rest-fulness) of being able to create something that isn't directly caught in the trap of language and dodges the responsibility each sentence inevitably carries with it—in short, a sort of innocence that writing denies me.

Bernard Faucon

In summer 1976, the photographer Bernard Faucon began a series of photographs based on what he describes as a 'possible equation between photography and mannequins'. The resulting work, produced between 1976 and 1981 and mainly shot in the south of France, came to be known as 'Les Grandes Vacances'. In 1990, the mannequins were shipped to Japan, where they now reside in the collection of the Nanasai Company of Kyoto.

Barthes's fascination with these photographs is further confirmed by a handwritten note he is known to have sent to their creator.

Oeuvres complètes, Volume 5, pp. 471–4

Bernard Faucon has photographed (real and/or simulated) children. However, the motive behind his venture (the question underlying it) is neither the love of children nor photographic art. Or, at least, we can say that, by the unease these images cause us, the genuine puzzle they pose and leave dangling before our eyes—which cannot look away and yet cannot pierce their mystery—we doubt (ultimately) that in Photography, that great unknown of the modern world, there is the *subject* on one side and, on the other, an approach [*une manière*]; in short, we doubt whether photography is really nothing more (though the idea is commonly held) than the combination of an argument and an art.

This is a grave doubt—proportionate to the astonishment these photographs arouse in us. And these words themselves are inadequate; with them, we remain captive to our tendency as Westerners to assign any change in our identity to the register of pathos. An Eastern (Japanese) word would fit the bill better, that

word being *satori*—a jolt, shock or descent into oneself that suddenly grips the Zen disciple and enlightens him as to the void within. It isn't possible to say what *satori* is, but, as far as Bernard Faucon's photographs are concerned, we can divine what region it comes from: the region of *heterology* or the place where different languages rub up against one another and heterogeneous natural species come together. Mannequins—objects we already apprehend solely in terms of their status—are met a second time, unexpectedly, among a host of real objects—objects familiar, worn and in use (candles, bottles, slices of melon, unmade beds, moving swings, etc.)—against a backdrop so romantic that its natural character is heightened (the vastness of hills, gardens and sea) and caught in everyday scenes of play. Alternatively, and more insidiously, heterology results from the fact that the euphoric expression of the waxen faces is, as it were, *preserved forever* independently of the actions in which the mannequins are engaged. What could be more disturbing than a look that both *extends* and defies the law of expression—that is to say, the correspondence between inside and outside, cause and effect.

Artificial bodies, statues, mannequins, automata and androids have always unsettled human beings—this is, literally, a mythic question. Bernard Faucon's work is clearly a variation of the myth. Here is how I sense that the dialectic of this variation runs: first of all, by virtue of their origins, Bernard Faucon's mannequins

seem to press two images on us: the image of childhood (little boys in short trousers, gangs of children, games and play), and the image of the shop-window from which these mannequins are taken. Now, these images are thwarted, foiled: childhood, the mythic age of freshness, spontaneity and purity is compromised here by the artifice of bodies that are set rigid (even though their gestures might have 'life' to them, their stares remain fixed). And the shop-window, a glass box, is entirely open to nature, to houses and rooms. With the natural surroundings and the skilful balancing of the poses, Bernard Faucon takes his mannequins out of the shop-window. The result is an enigmatic reversal: the real body that appears in certain scenes (as victim) can barely be distinguished from the mannequins with which it is mingled, giving reason to doubt its fleshly nature. What separates the true from the factitious is tenuous in the extreme, and disturbingly so. The true is to be sought not in 'reality' but in *art*, conceived not as expressive, humanist value but as the foundation— or accomplishment—of artifice. The true body has an impossible 'role' and thereby demonstrates truth. Baudelaire perhaps had some presentiment of this dialectic when he spoke of 'the emphatic truth of gesture in the great circumstances of life.'[1]

1 Charles Baudelaire, 'Exposition universelle, 1855. Beaux-Arts: Eugène Delacroix' in *Curiosités esthétiques* (Paris: Michel Lévy Frères, 1868), p. 237.

ROLAND BARTHES

Bernard Faucon *arranges* the scene he is going to photograph. What he produces is, very exactly, a *tableau vivant*. This still scene he entrusts to the very art of Stillness: Photography (the—currently stalled—theory of Photography will never advance as long as we insist it is the mission of that art to give life and animation to those things that have neither). In this way, a circuit is established, whose meaning cannot be pinned down. Bernard Faucon doesn't photograph a *tableau vivant*: he produces a photograph *doubling up* as a *tableau vivant*; he combines two immobilities. Instead of dividing the Image (as is ordinarily done) into content and form, referent and signifier, he heaps together two forms, two signifiers; in so doing, he contradicts the nature of the Image itself, which etymologically, by its Indo-European root (*yem/im*), refers to a 'double fruit'. He produces a barely tolerable unity, a unity that is 'against nature'—that is to say, supernatural. In its very derisoriness, the photographed *tableau vivant* forcefully evokes a certain idea of the Immortal—these infra-bodies, whose stationary nature is heightened by the whole artifice of life surrounding them, are apprehended by the artist as though it was their destiny to be resuscitated.

Zoom (October 1978)

The Interval

Oeuvres complètes, Volume 5, pp. 475–7

This article, a review of the exhibition *Ma. Space-Time in Japan* at the Musée des arts décoratifs in Paris, was originally published in the left-leaning mass-circulation weekly *Le Nouvel Observateur* on 23 October 1978. The magazine published it as 'Entre l'angoisse et l'amour' (Between Anxiety and Love) but Barthes's original title has been restored here.

Not far from the avenue de l'Opéra, a place where little groups of Japanese petty bourgeois buy perfumes and souvenirs, there is an exhibition to remind us that Japan isn't just this by-product of economic success. Can we really call it an exhibition? Not exactly. What is being offered to the public here isn't a coded Japan, whether a country of folklore or modernity or an artistic or industrial nation: geishas are present, in one corner, only rather derisorily as figures on postcards; cities are shown in panoramic views but in apocalyptic, Hiroshima-esque mode; Noh theatre is there but curiously as illustration of an entirely secondary phenomenon, the play of flickering light and semi-darkness.

Is there, at least, a theme (for we too have themed exhibitions)? There is, but that theme is quite a peculiar one—it is a concept but not one familiar to us, for, while we are more or less at home with the ideas of

time and space, Japan doesn't seem to make that distinction. What it feels, and expresses, is something common to both space and time—*ma*, which is any relation between two moments, two places, two states. The syllable itself is so simple that it seems to be telling us—we who are often forced to complicate words to express the complexity of what they mean—'Don't worry, it's not difficult, it's something very simple and very direct, you'll see.' And the exhibition (there's no emphasis there; in fact, it's more of a meditation) plays variations, from one room to another and one display to another, on this idea of the interval.

In this way we discover certain subtleties (Proust: 'You say they are subtleties: they are realities'). For example, *yami*: that which flickers, twinkles or emerges briefly from the half-darkness; *utsuroi*: the moment when the flower is about to fade, when it is as if the soul of something is suspended in the void, between two states; or *sabi*: surface wear, rust, patina.

This event is peculiar in the following sense also: ordinarily, an exhibition is objective; it informs but doesn't think. Here, by contrast, it has been conceived by a man, Arata Isozaki, whose subjectivity it openly expresses—his tastes, fears, nostalgias (this being said in the attempt once again to combat the prejudice that what is intelligent cannot be emotive). Isozaki's first emotion is the love of fine things for their connectedness to the past. This isn't about folklore or antiquities. There are, in the exhibition, some very

modern sculptures and arrangements, but that modernity is in thrall to a very old style, steeped in metaphysical values whose *ethnically marked* character we know well—from zen gardens, the layout of Japanese living rooms, calligraphy and haikus (books by Munier and Coyaud have recently reiterated the importance of the latter). Practising *ma* in our turn, we shall refer to these not as things of the past but as things that *come from the past* by a flimsy but insistent spiritual filiation—things that bridge the gap between modern materials and ancient nobility.

Now, the exhibition also says that this nobility is threatened by an ever-increasing quantity of vulgar, gaudy objects. Hence the historical question put by Isozaki: Why and how are objects—and, even more to the point, the spirit of their daily arrangement—degenerating into enormous quantities of worthless trinkets? Isozaki's second emotion is an anxiety—an obsessive fear of the great cataclysm threatening Japan's enormous cities. Two images, apparently far removed from each other, express this fear: a view of Hiroshima devastated by the bomb and, not far away, the subtle, cruel transformation of a woman's body, seen moving through four finely drawn stages, first to a corpse, then to a decaying carcass, then to a skeleton.

If I have stressed the intellectual and emotive sense of this exhibition, that is because it stands itself under the principle it illustrates—'discretion' (the word is merely an approximation). All in all, there are few

things to 'see'. You won't feel the giddiness induced by European museums, won't experience the mad, though soon wearied, excitement at rooms packed with a hotchpotch of exhibits. There are a few panels, a few structural elements (most delicately crafted), a few abstract sculptures (in glass and copper), some photographs and a painting (some pines in the mist fill the entire space). Because of this very scarcity of exhibits, a kind of contemplative atmosphere descends. Sight, the faculty normally called on in exhibitions, gives way to a more diffuse sensibility, a subtle play between the materials and the surrounding semi-darkness (*ma* again). This calmer feel (though also, perhaps, a difficulty apprehending the exhibits) arises too from the fact that the symbolism of the arrangements is extremely elliptical. Ideas are suggested by the nimblest of mediations: *sabi* (a slow and apparently changeless fading of substances) is, in this case, a beige cloth thrown on the ground (it could be something quite different), whose subdued sheen and shimmering evokes the idea of patina (beauty and destruction). This is because, over in Japan, the symbol doesn't reduce to an emblem—it is a fluid, free, instantaneous transience that isn't part of any lexicon: 'All that passes away is only a symbol,' says Schumann's Faust.[1]

1 'Alles Vergängliche ist nur ein Gleichnis'. The words are originally Goethe's. [Trans.]

ROLAND BARTHES

There Is No Man

Despite his admission in an interview for *France Culture* that he was no great cinema enthusiast, Barthes agreed to travel to Yorkshire in 1978 to play the small part of William Makepeace Thackeray in André Téchiné's film *Les Soeurs Brontë* (The Brontë Sisters). The film was released on 9 May 1979 and this review in *Le Nouvel Observateur* appeared a week later.

The title of the piece—'There Is No Man'—is a line from the film: Charlotte is explaining to George Smith, her publisher, that all the writers concealed beneath the pseudonyms Currer, Ellis and Acton Bell are, in fact, women.

Oeuvres complètes, Volume 5, pp. 659–61

The Brontës' story has something mythic about it (literature too has its myths). These three sisters, raised as a clergyman's daughters on the rather desolate Yorkshire moors, each wrote verse and novels initially published under a quasi-collective pseudonym (only the Christian names were different). Two of the novels belong to world literature: *Jane Eyre*, written by the eldest sister Charlotte; and *Wuthering Heights*, written by the younger Emily. How could works of such talent—and, above all, of such harshness and violence—emerge from this pastoral country milieu, and how could they have been written by women (a surprising phenomenon in the eyes of their century)?

André Téchiné's film doesn't destroy this myth, but it has an unexpected take on it. The film has a title, *The Brontë Sisters*, but it also has a hero—the brother. That brother (who really lived, and even wrote) is the return of the repressed in the Brontë story. This repressed element is not triumphant. Branwell, replete with desires and gifts, achieves nothing. He dies of

alcohol, opium and failure. Eaten away and destroyed from the inside, he gradually grows bent and bowed (as can be seen from his silhouette). He breaks down, surrounded by his three sisters who are watchful, strong (at least morally) and yet powerless, for though the three of them together can drag him from his burning bed, they cannot cure him of the 'marasmus' from which he dies.

The story told is the subtle one of what we might call a family micro-network. Each member has his or her personal passion: Charlotte for the head of her Belgian school ('love of the authority figure'); Emily probably for her brother; and the brother, though impulsive, for the mother of his pupil. Of Anne, the youngest of the sisters, we know nothing. However, stronger than these divergent passions, there is the congenital collusion (which it certainly was) of the old clergyman's four offspring—they spent their childhood in the vicarage and out on the moors devising stories together (Raymond Bellour has studied these four-handed fabulations elsewhere). And because this small milieu is a highly homogeneous one, the differences that gradually emerge among the partners to the game have something darkly tragic about them, since they owe nothing to the circumstances or even to the characters but, rather, are down to a sort of moral biology (if I may be permitted the expression), which means that these human plants evolve differently depending on the place they occupy within the order of the sexes.

Though all three sisters are mysterious, they doubtless do not have the same degree of mystery. Emily (Isabelle Adjani: to differentiate the roles, we have now to mention the actors) is wild (she prefers holly to flowers) and imperious. Charlotte (Marie-France Pisier) is noble and thoughtful; she is the best integrated personality and we know who she is in love with (which always make a character seem more ordinary). She will marry, survive and enjoy a little of her literary fame (she is invited into Thackeray's box at the opera). Anne (Isabelle Huppert) is gentle and laconic; nothing happens to her, but by that very token she brings the group of sisters to a state of perfection for, since there are three of them, they really form a group, a kind of sororal entity. And it is against this group (though included in it) that the death of the brother (Pascal Greggory) will play out.

His death? More his obliteration. The young Branwell, full of hope and confidence, painted a picture in which he depicted himself among his sisters. At some later date, however, he took a sponge and erased his image. The three sisters remain—and their books. The man was rubbed out. 'There is no man,' says Charlotte to the publisher, who is stupefied to learn that these powerful novels were written by women. With this, historically, mythically, creation changes sex. It is over to the other sex now, as we might say. The man is the repressed; he has no other face than that of a slow defection. 'I wonder what he might look like, this brother?' says one of the characters

in the film, in which the men are not well favoured by nature, if we except the charming young Frenchman who welcomes the sisters, reading Balzac to them in the publisher's outer office.

A family story? Yes, but there is something rather new here, I believe, in that we're no longer talking of a parental family, in which the conflicts are between parent and child, but a sororal family, a strange 'horde' (to use Freud's term), in which it is the sisters who struggle for (creative) power while the man, the brother slides into decline. For, if it is true that we have entered upon a crisis of fatherhood, seeking by turns to kill, rehabilitate, feminize him, etc., André Téchiné's film doesn't murder that father (we even see him figuring in his new place, that of passer-by), it neutralizes him. It simply says that the reference to the Father isn't necessary to depict the rivalry (deeply loving as it may be) between the children.

Such is the story told by André Téchiné and Pascal Bonitzer, the authors of the screenplay. I am told that in cinema the screenplay doesn't count for much and everything is down to the direction. I don't believe that at all. As I see it, the story is crucial. The story is what I see carved out by the little hole of the *camera obscura* (there has to be something at the end of the lens—a meaning and not mere phantoms). As for *cinema*, it is the light and the time, the force and the patience by which that story comes to impress itself not only on my eyes but also, beyond that, my memory.

André Téchiné's film remains in my head like a song. The austere beauty of its landscapes and the individuality of its faces keeps it singing for a long time. I see these again inwardly, like the faces of a beloved family: that of Adjani, such a beautiful mask, though tensed and closed; that of Pisier, who seems always to be cogitating seriously on what she is seeing and experiencing; that of Huppert, charming and yet reserved to the point of silence, of mysteriousness; that of Hélène Surgère, a face of supreme maturity, yet so subtle; that of Pascal Greggory, whose natural grace is tragically blighted by the progressive decline of the character.

In this way, I see again the faces of all those I worked with for a few days in England. No doubt friendship plays its part in my memory, but I believe too that I couldn't have pondered the ins and outs of this film, couldn't have derived a strong meaning from it, if the roles hadn't been played with precision—in all their diversity—and with everyone fully committed to the project.

Note on an Album of Photographs by Lucien Clergue

This text on Lucien Clergues's book *Language des sables* (Language of the Sands), which was among the last of Barthes's writings, was originally published in the Marseille-based *Sud* in February 1980. According to a note in Barthes's Complete Works, it was subsequently reprinted as the preface to the book in 1981, but it appears already to have featured as the preface to the first edition in 1980 (Marseille: Agep).

Oeuvres complètes, Volume 5, pp. 895–7

Lucien Clergue's photographs are beautiful and their beauty is widely recognized. My role, as it seems to me, isn't to speak of them on the aesthetic level but, rather, to try and say what they have about them of the intellective. I note immediately that the collection Clergue has entitled *Le Langage des sables*, with which I am concerned here, is from the outset a discourse, since these photographs have been subjected by their author to a classification which is always an object of knowledge. Moreover, since they reproduce a referent, they necessarily mobilize a code of reproduction and hence open themselves in a second respect to analysis.

———

In the way we apprehend objects, we too often forget one factor that is, after all, decisive—the level of perception. By merely subverting the size of the objects presented, we create entirely new objects, even though the referent is still the same. To change the level of

perception is to reveal the unknown; let us recall the Flea magnified by a microscope presented in Diderot's *Encyclopédie*—it is a horrendous monster that seems to have escaped from some prehistoric adventure film. We may recall also how someone aptly commented that the whole of Nicolas de Staël came out of five square centimetres of Cézanne. Clergue too changes the level of perception of beaches—with the tiniest quantity of sand, he creates a giant relief. He breaks down the barrier of names—a wisp of grass becomes a tree, a string of seeds a whole mountain range. In this way, he confounds perceptual and nominal prejudices, unmakes and remakes identities and names—which, all things considered, is the very function of living knowledge. Sands are no longer a vast, even, featureless expanse, but a thousand other things—Clergue makes different sands.

Clergue's work doesn't necessarily 'mean something' but it definitely *has meaning* and thereby moves us—what could be more human than a man with a meaning to convey, without our quite being able to know what that meaning is. Semiology, or the science of signs, has a purchase on Clergue's work at two points.

———

Clergue creates forms that evoke other forms. Striations in sand evoke the idea of fossilized bracken, a blade of grass a hair, folds in the sandy surface parts of the human body (clefts, hollows, rotundities); little

cracks evoke not some particular script but the very idea of writing (of written signs). Here, curiously, we are back at a certain prehistory of writing—it is said that Chinese ideography emerged from the little cracks in tortoise-shell heated white hot, and Leroi-Gourhan has suggested we might see a sort of origin of writing in the rhythmically spaced incisions of cave art. All this coincides quite closely with the state of the sands Clergue presents. This movement, this to-ing and fro-ing of forms is part of a general operation which, in discourse analysis, we call metabole; I prefer this term to the better known 'metaphor' for, ordinarily, metaphor implies the idea that the image is anchored somewhere beyond itself—in short, that it has an origin. Now, the sand patterns traced by Clergue are simply forms in transit; they don't imply a literal state that can serve as a standard or origin (as happens in Arcimboldo's composite heads)—there isn't *a* meaning; there is *meaning*.

————

In the *suite* of photographs (I use the word in an almost musical sense), there is also meaning rather than *a* meaning. That meaning is vaguely cosmic. In arranging his sand images, Clergue charts the course of a progressive emergence out of primal chaos; thus, from form to form, he advances from streaming water to manufactured objects, to plastic debris. Hence the series functions here as an Allegory (in the broad sense)—as malleable material, sand is the allegory of

a process of becoming. I should like to add, as a personal note, that in the very great disarray we often find ourselves in when judging a modern work (image or text), the presence of an allegorical process is a sign of worth in my eyes: once again, it matters little what a work signifies—what counts is that there is signification within it, that it has meaningful intent: the meaning in it has to call out to us. Adapting a line from Keats, I shall say that 'A photographer's photography of any worth is a continual allegory.'[1]

———

When a work exceeds the meaning it initially seems to convey, that is because there is a poetic element in it: the Poetic is, in one way or another, the supplement of meaning. From this point of view, Lucien Clergue's suite includes two poetic supplements. First of all, Clergue insistently employs a favoured form—the Trace. Now, the Trace is an intermediate sign, it is either not properly achieved or over-achieved, a transitory index of we know not what. Here the photographer is like a trapper or an archaeologist, following something by studying its tracks or traces. Through this cultivation of the Trace, Clergue engages with two distinct orders of Photography. The first is painting (we need only think of the recent painters who are proponents of the Trace—Michaux, Masson, Twombly).

1 Keats: 'A man's life of any worth is a continual allegory.'

The second is Magic, which is essentially an inspired reading of traces or signs. For the pagan, nature is merely that surface of the Earth that has been marked—like Clergue's sands—by the imprint of the Gods. Clergue's suite is almost a treatise of geomancy. A second path of the Poetic is the theme. In Clergue's collection, a single thing is said endlessly and that thing is a substance—sand. Ordinarily, sand prompts a thematics of dryness, volatility, deserts and infertility. Clergue's sands are wet sands, docile and responsive to the forces of wind, sea, animals and man. Admittedly, they are not yet primal mud, the stuff of fecundity, but, like the photographic film that registers them, they are already sensitive to a certain *work* of nature and man, and ready to *bear its stamp*.